FEDERICO ZERI (Rome, 1921-1998), eminent art historian and critic, was vice-president of the National Council for Cultural and Environmental Treasures from 1993. Member of the Académie des Beaux-Arts in Paris, he was decorated with the Legion of Honor by the French government. Author of numerous artistic and literary publications; among the most well-known: *Pittura e controriforma*, the Catalogue of Italian Painters in the Metropolitan Museum of New York and the Walters Gallery of Baltimora, and the book *Confesso che ho sbagliato*.

Work edited by FEDERICO ZERI

Text
based on the interviews between
FEDERICO ZERI and MARCO DOLCETTA

This edition is published for North America in 2000 by NDE Publishing*

Chief Editor of 2000 English Language Edition
ELENA MAZOUR (*NDE Publishing*)

English Translation
SUSAN SCOTT

Realization
ULTREYA, MILAN

Editing
LAURA CHIARA COLOMBO, ULTREYA, MILAN

Desktop Publishing
ELISA GHIOTTO

ISBN 1-55321-010-7

Illustration references

Alinari Archives: 1, 2-3, 4, 5, 6-7, 8, 9, 10c, 17d, 22b, 24, 25, 28, 29s-d, 30, 31ad, 43b, 44/VII-IX, 45/III-IV-V-VIII-IX, 46.

Luisa Ricciarini Agency: 11a, 16bd, 17c, 23bd, 36-37, 41cd, 44/III, 45/II.

RCS Libri Archives: 14a, 16as-bs, 16-17, 18, 19as-ad, 20, 21, 22a, 23a-bs, 26, 27b, 31bs-bd, 34-35, 35a-c, 38-39, 44/IV-V-VI-X-XI, 45/VI-VII-X-XI-XII-XIII-XIV.

R.D.: 2, 10a-b, 11bs-bd, 12-13, 14b, 14-15, 19b, 27a, 31as, 32, 33, 35b, 40, 40-41, 41, 42, 43as-ad, 44/I-II-VIII-XII, 45/I.

Printed and bound by Poligrafici Calderara S.p.A., Bologna, Italy

* a registered business style of NDE Canada Corp.
15-30 Wertheim Court, Richmond Hill, Ontario
L4B 1B9 Canada, tel. (905) 731-1288

The captions of the paintings contained in this volume include, beyond just the title of the work, the dating and location. In the cases where this data is missing, we are dealing with works of uncertain dating, or whose current whereabouts are not known. The titles of the works of the artist to whom this volume is dedicated are in blue and those of other artists are in red.

MATISSE
LA DANSE

Matisse is the great twentieth century poet of color. Playing on curved lines, soft outlines, movement, and bright colors, in LA DANSE he succeeds in creating an abstraction of reality in a painting that is nonetheless

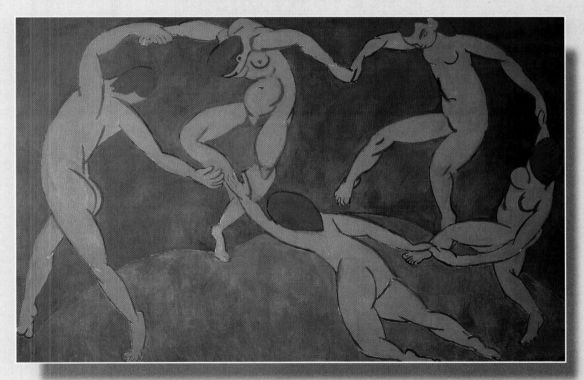

representational. Commissioned by the Russian collector Shchukin in 1910, Matisse's LA DANSE was conceived for the snowy city of Moscow: in the midst of the long white streets, with the dazzling light reflected off the snow, this vision emerges of bright, almost feverish color.

A MASTERPIECE RESCUED

LA DANSE
1910

● St Petersburg, The Hermitage (oil on canvas, 260x389 cm)

● *La Danse* was painted in 1910 on a commission from one of the leading collectors of contemporary art, Shchukin, who gathered in his large house in Moscow some of the masterpieces of nineteenth century French and of Oriental art, with a watchful eye also on the new century's latest trends. To decorate the staircase in his home, Shchukin asked Matisse for two large canvases of the same size: *La Musique* and *La Danse*.

● After the October Revolution the collection, a prodigious one for its selection of works of the highest quality, was confiscated by the State. Shchukin lost ownership and became simply the curator of his own house, attempting to maintain the original arrangement of the paintings on the walls.

● With the advent of Stalinism, the collection was dispersed; part was given to the Pushkin Museum in Moscow, at the time the New Museum of Modern Western Art, and part put in the Hermitage in St Petersburg. *La Danse*, deprived of its frame designed by Matisse specifically for Shchukin's rooms, was removed from the place where it had been conceived to hang. In the period immediately after the war, with the great campaign against Western culture, as the Cold War heated up, it risked being cut into pieces. It was saved by sheer chance by some curators who put their efforts into hiding the art works.

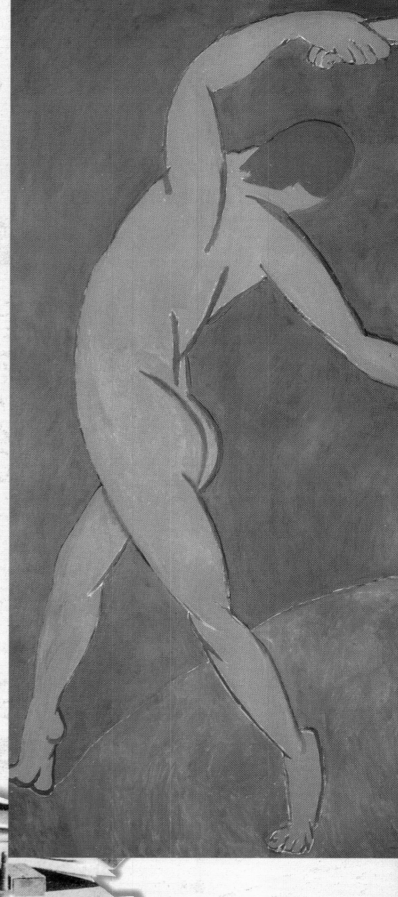

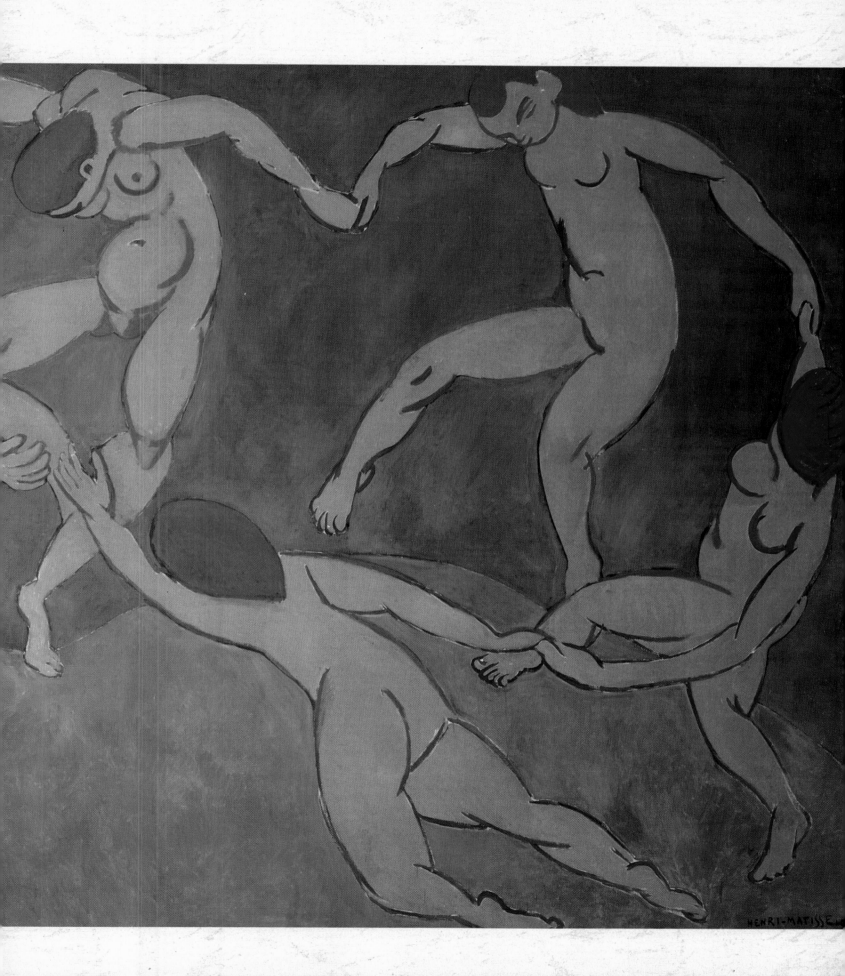

THE MOVEMENT OF COLOR

Matisse arrived at *La Danse* after a long study of nudes in the open air. His two versions of *Le Luxe*, of 1907, and *Bathers with a Turtle*, of 1908, brought him into the universe of curved lines and the Cubist experiments of the late Picasso.

● In 1909 he painted a first version of "*La Danse*," now in the Museum of Modern Art in New York, and in 1912, in *Vase of Nasturtiums with La Danse*, he moved another step towards working out the composition and chromatic tones of the work.

● The scene takes place on a green hill against a nocturnal, almost dark, blue background. The red figures flicker like flames in broad, well defined movements. In the background we can almost hear the notes from Pan's pipe. The five nudes – a departure from the canon for circular compositions, which calls for an even number of figures – arrange themselves in a wide circle. In the foreground, the two reaching hands, which do not quite manage to touch, create a break in the movement, but the figure seen from the back in the foremost plane resolves the compositional structure. Stretching in a powerful lunge, she forces the nude on the left to pivot, a movement which he in turn transfers to the two in the background. The fifth figure closes the circle, dragged along by the force of the others' gestures.

● In 1970, the centenary of Matisse's birth, for the great retrospective exhibition of the master's works held in the Palais Royal in Paris, *La Danse* and *La Musique* were loaded onto an Antonov, the only airplane with a hold big enough to contain them.

● With the frame and lighting studied for it by Matisse, struck in the winter months by the reflections off the snow of Moscow, this new version of the Bacchic and pastoral theme (whose depiction was almost always constructed around a circle dance) must have produced a dazzling effect on the wall of Shchukin's stairwell. Conceived to be seen from far away, in the museum, away from its original setting, it seems almost to have been betrayed.

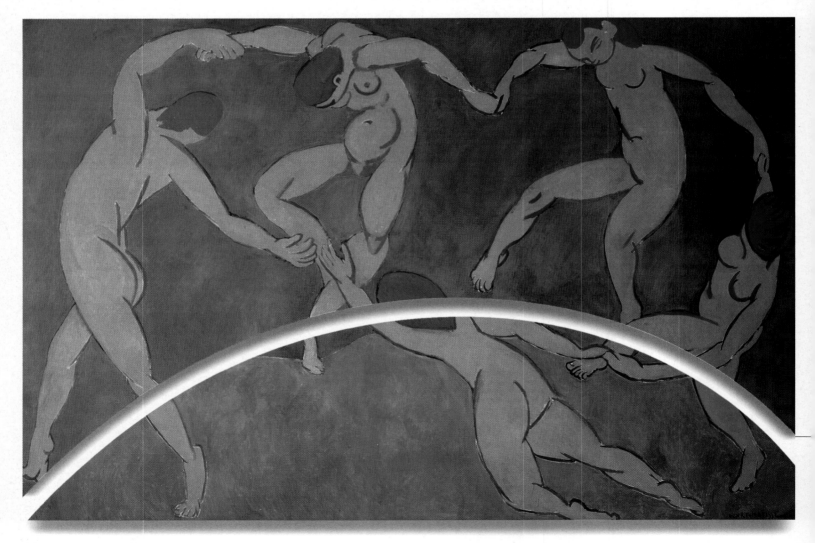

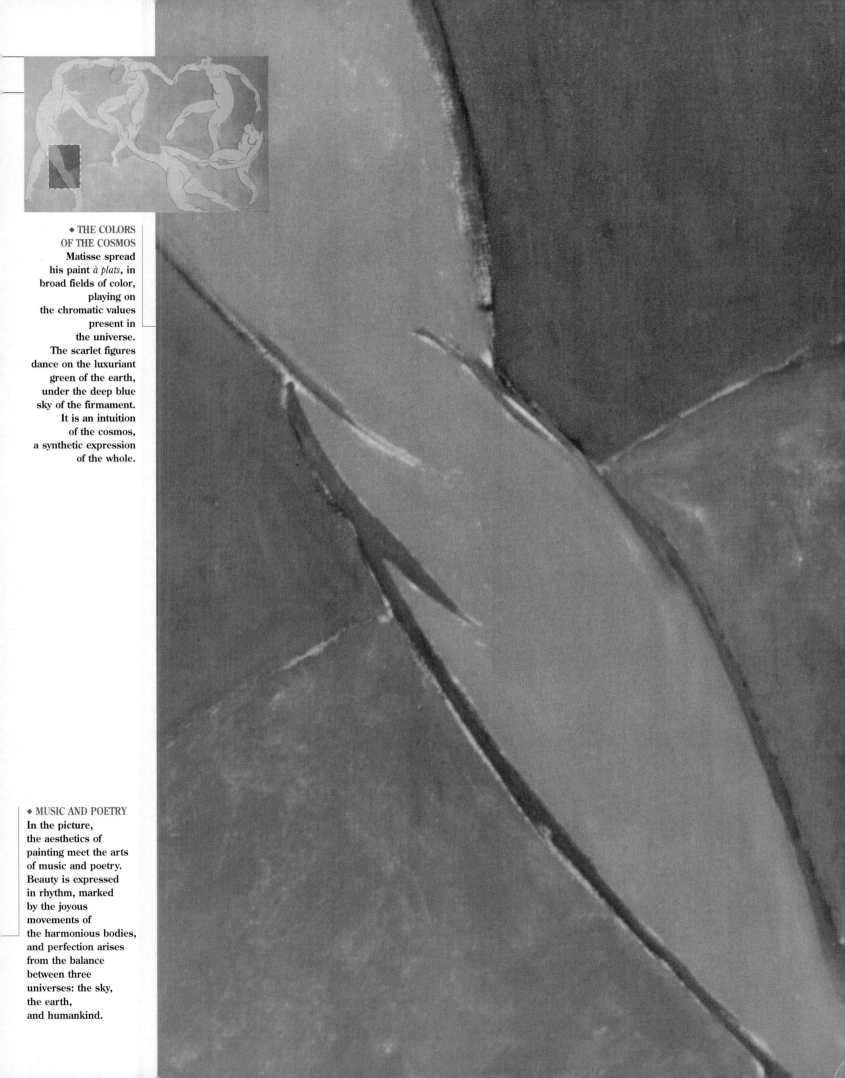

◆ THE COLORS
OF THE COSMOS
Matisse spread
his paint *à plats*, in
broad fields of color,
playing on
the chromatic values
present in
the universe.
The scarlet figures
dance on the luxuriant
green of the earth,
under the deep blue
sky of the firmament.
It is an intuition
of the cosmos,
a synthetic expression
of the whole.

◆ MUSIC AND POETRY
In the picture,
the aesthetics of
painting meet the arts
of music and poetry.
Beauty is expressed
in rhythm, marked
by the joyous
movements of
the harmonious bodies,
and perfection arises
from the balance
between three
universes: the sky,
the earth,
and humankind.

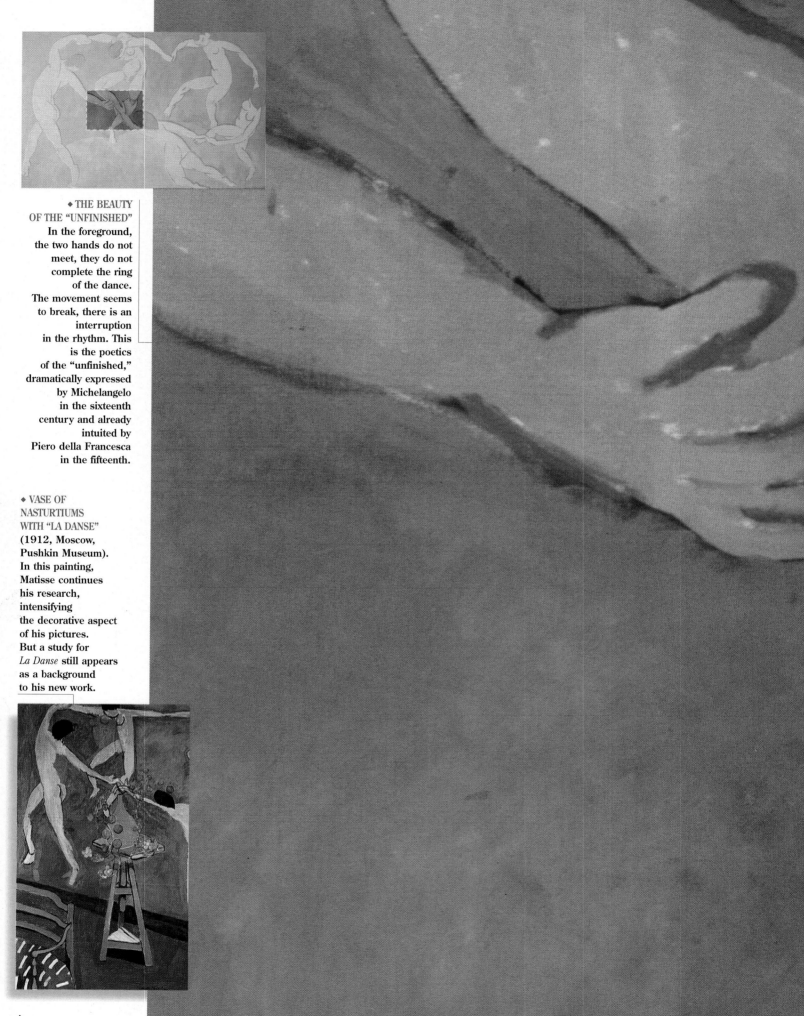

◆ THE BEAUTY
OF THE "UNFINISHED"
In the foreground,
the two hands do not
meet, they do not
complete the ring
of the dance.
The movement seems
to break, there is an
interruption
in the rhythm. This
is the poetics
of the "unfinished,"
dramatically expressed
by Michelangelo
in the sixteenth
century and already
intuited by
Piero della Francesca
in the fifteenth.

◆ VASE OF
NASTURTIUMS
WITH "LA DANSE"
(1912, Moscow,
Pushkin Museum).
In this painting,
Matisse continues
his research,
intensifying
the decorative aspect
of his pictures.
But a study for
La Danse still appears
as a background
to his new work.

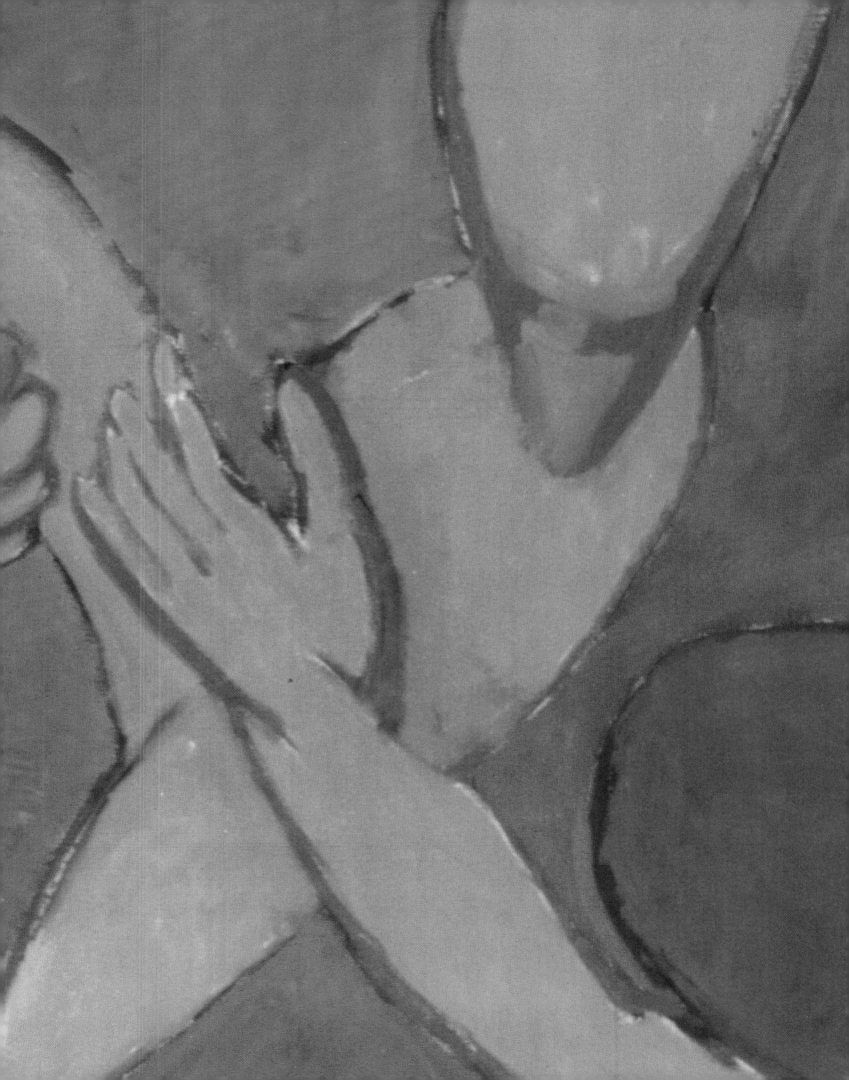

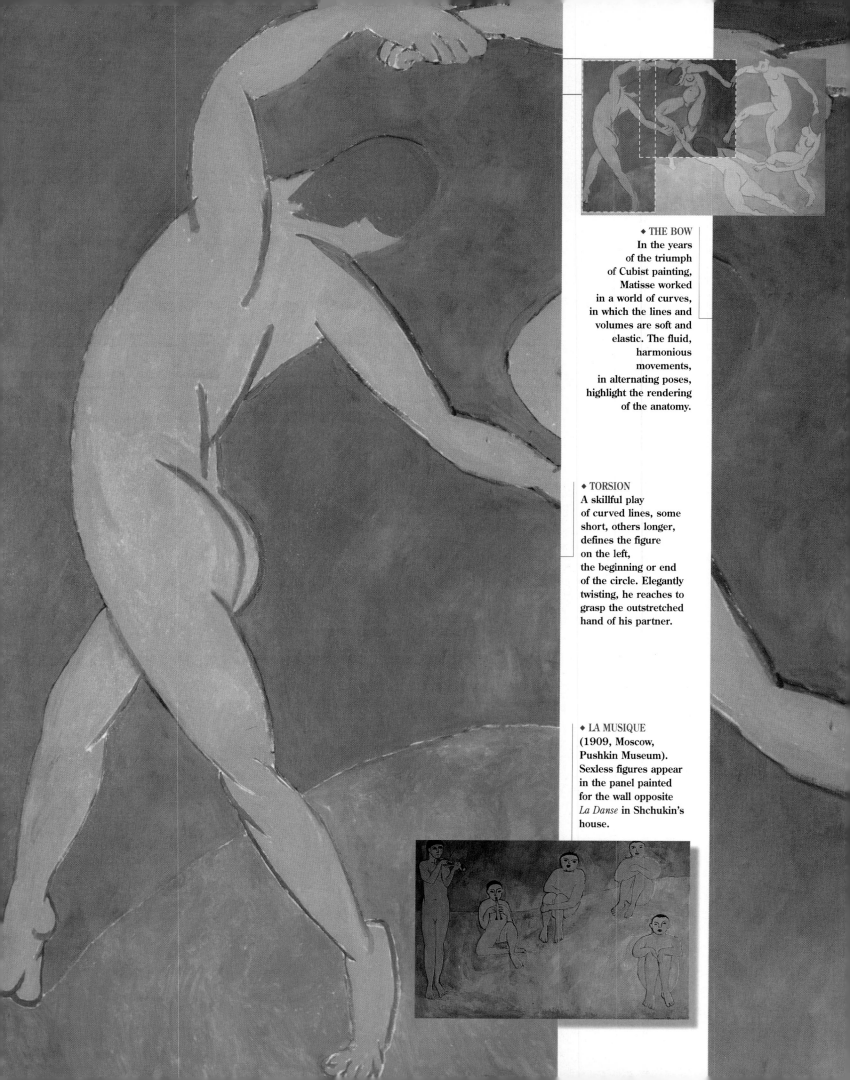

◆ THE BOW
In the years
of the triumph
of Cubist painting,
Matisse worked
in a world of curves,
in which the lines and
volumes are soft and
elastic. The fluid,
harmonious
movements,
in alternating poses,
highlight the rendering
of the anatomy.

◆ TORSION
A skillful play
of curved lines, some
short, others longer,
defines the figure
on the left,
the beginning or end
of the circle. Elegantly
twisting, he reaches to
grasp the outstretched
hand of his partner.

◆ LA MUSIQUE
(1909, Moscow,
Pushkin Museum).
Sexless figures appear
in the panel painted
for the wall opposite
La Danse in Shchukin's
house.

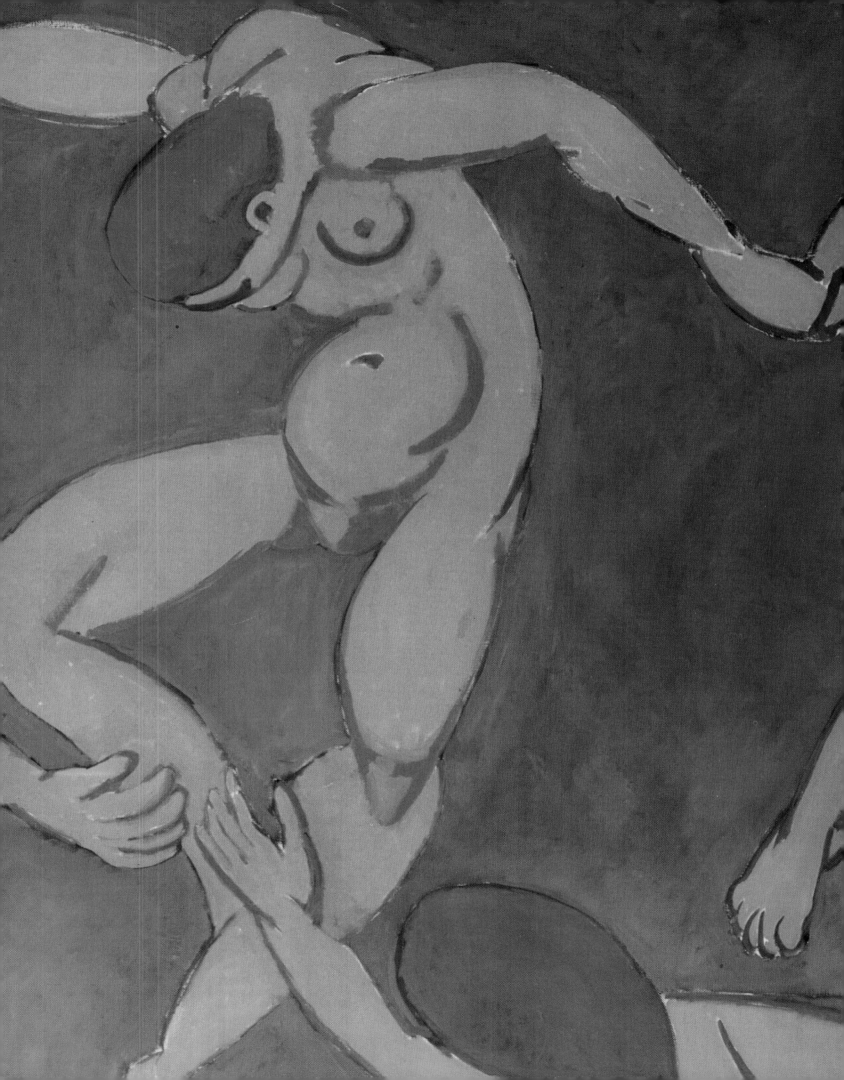

DANCING TO THE NOTES OF PAN

This large composition represents the meeting point between the teachings of the great innovative masters of the late nineteenth century and the new trends in painting appearing at the beginning of the twentieth. Present here are the primitivism of Gauguin's Tahitian paintings and his doctrine of arbitrary color, the flat spreading of the pigment of the school of Pont-Aven, Van Gogh's intensity of tint and his chords of surfaces of saturated colors, and Cézanne's study of composition.

● The bucolic theme of the Bacchanal has classical roots which were taken up and developed in the sixteenth century by Titian, in the eighteenth by Poussin and Watteau, and in the nineteenth by Corot. The classical topos of a nude in a landscape echoes Virgil's poetry and was represented in music at the end of the nineteenth century by Debussy.

● The theme of the open air nude is one of the principal concerns of the German Expressionists as well. Inspired by Matisse, the bathers by Müller, Kirchner, Schmidt-Rottluf, and Heckel flee from modern urban civilization and hide in an ideal nature, the nostalgic evocation of the Golden Age. German artists revived in particular the traditional motifs of their medieval period, returning to working with wood, and woodcuts became a cornerstone of their aesthetic.

◆ **KARL SCHMIDT-ROTTLUFF**
Bathers on the Beach
(1913, Hanover, Landesmuseum)
This German Expressionist painter seeks refuge in the peaceful universe of an earthly paradise (the figures display their nude bodies, heedless of the stares of onlookers). His painting style, more violent and dramatic, is made up of hard, broken lines and aggressive colors.

PRIMITIVISM

A fundamental theme for the German and French Expressionists, Primitivism sinks its roots in the nostalgic return to the Middle Ages and the archaicism of the early Romantics.
The love of the exotic which bloomed at mid-century fed an ethnological curiosity for non-European cultures. With colonialism and the first expeditions into Africa, the primeval art of the indigenous tribes was discovered, and the first wooden masks were brought into Europe. The Museum of African Art was established at the Trocadéro in Paris, and at the Louvre Egyptian archaeological finds and Romanesque and Gothic art were studied. This was the beginning of a new trend which traversed the folk religious tradition of Gauguin and the school of Pont-Aven to arrive at the turning point to Cubism marked by Picasso with his *Demoiselles d'Avignon.*

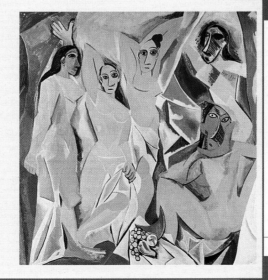

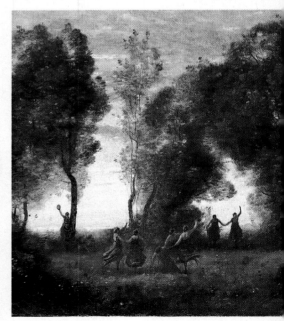

◆ **PABLO PICASSO**
Les Demoiselles d'Avignon
(1907, New York, Museum of Modern Art).
Picasso takes his inspiration for his bathers' faces from African masks.

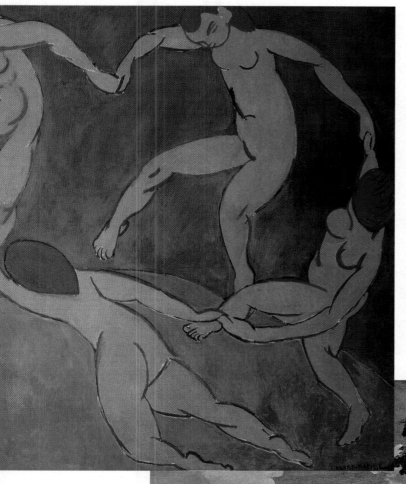

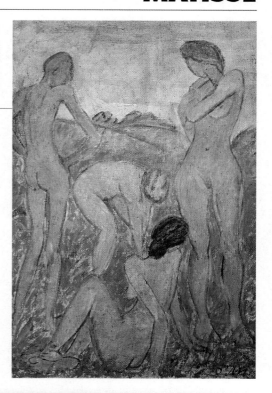

◆ **OTTO MÜLLER**
The Judgment of Paris
(1910-11, Berlin,
Nationalgalerie).
A member of the
German group called
Die Brücke
(The Bridge), Müller
expresses the desire
to flee from the
violence of the cities
which were preparing
for world war and
to take refuge in
the peace of an Eden.

◆ **TITIAN**
Bacchus and Ariadne
(1522, London,
National Gallery).
In the sixteenth century,
painting took many of
its themes from classical
literature. Titian depicts
celebrations of the god
Bacchus and
the dance of nude,
intertwining bodies.

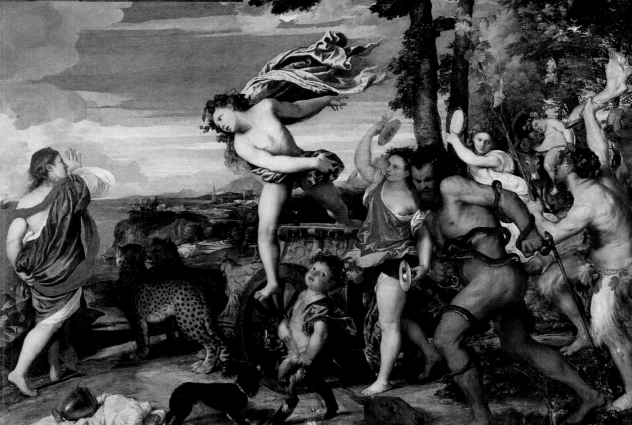

◆ **CAMILLE COROT**
*A Morning, the Dance
of the Nymphs*
(1850-51, Paris,
Musée d'Orsay).
Corot adheres
to the classical
landscape tradition,
with dancing maidens.

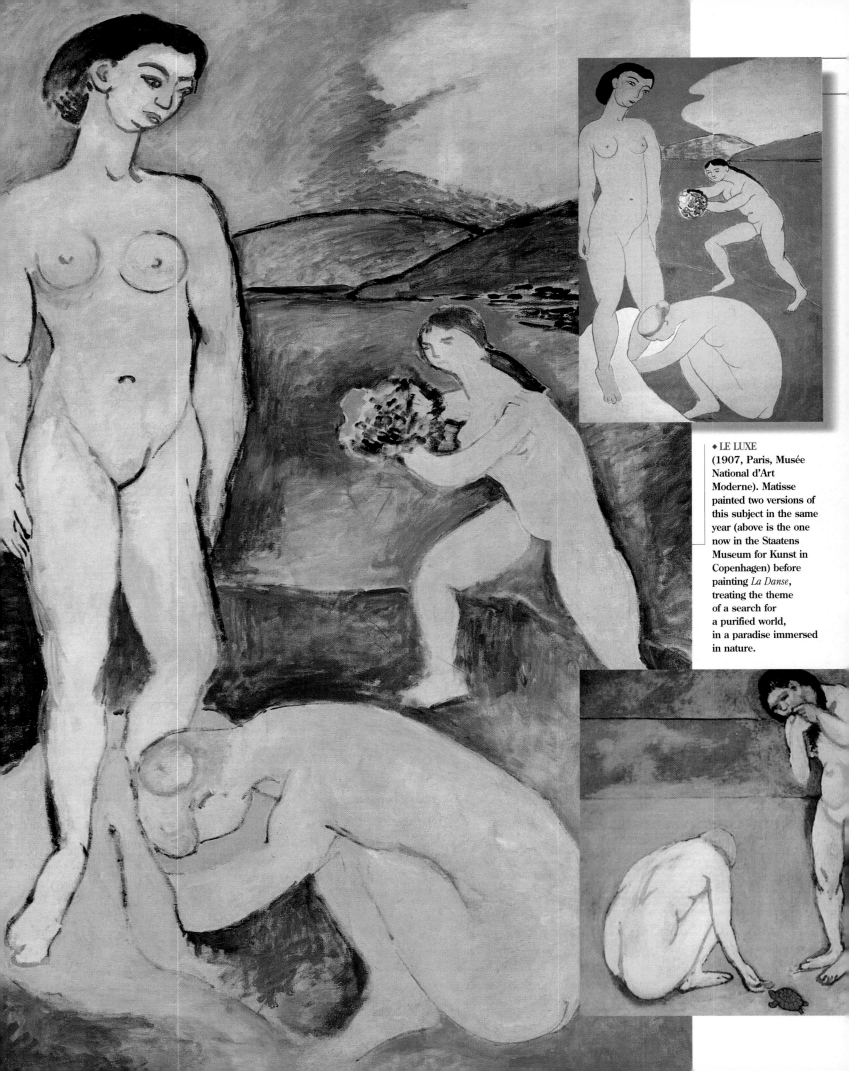

◆ LE LUXE
(1907, Paris, Musée
National d'Art
Moderne). Matisse
painted two versions of
this subject in the same
year (above is the one
now in the Staatens
Museum for Kunst in
Copenhagen) before
painting *La Danse*,
treating the theme
of a search for
a purified world,
in a paradise immersed
in nature.

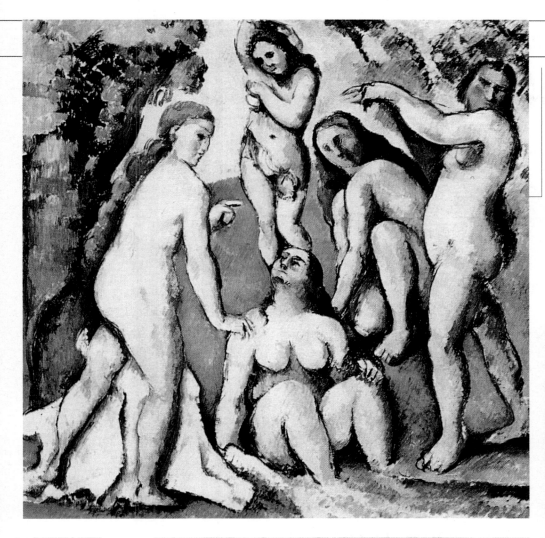

♦ PAUL CÉZANNE
The Five Bathers
(1885, Basel,
Kunstmuseum).
In its study of volume
and curved lines, this
is the representation
closest to Matisse's
universe. The number
of figures, too,
corresponds to that
of the dancers
in Matisse's canvas.
Already devoting his
attention for some time
to the depiction
of pleasure, beginning
as early as *Luxe, calme*

et volupté of 1904,
the artist dwells
on the study
of the nude in nature,
a concrete expression
of the flesh in intimate
enjoyment of the spirit
and the senses.
Sensuality reaches
its peak in the series
of odalisques.
The female bodies yield
themselves
voluptuously
to the painter's eyes,
as he observes them
for hours looking
for just the right pose.

♦ BATHERS WITH
A TURTLE
(1908, St Louis,
The St Louis Art
Museum).
Matisse here studies
curves and color.

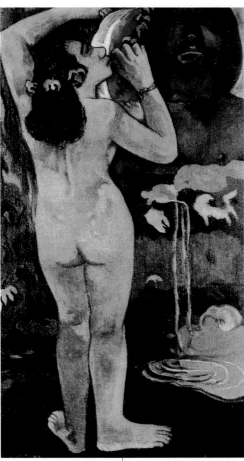

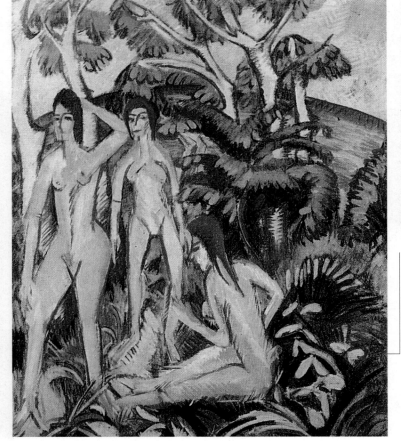

♦ ERNST LUDWIG
KIRCHNER
Bathers Under the Trees
(1913)
These bathers
by Kirchner, a leading
figure in German
Expressionism,
rest under the trees
at a distance from
the water. Their bodies
are angular and hard,
like the artist's violent
painting.

♦ PAUL GAUGUIN
Earth and Moon
(1893, New York,
Museum of Modern Art)
From the earthly
paradise in Tahiti where
he fled, Gauguin sent
back to the West
the harmony of a
primitive, uncontaminated
body. This is the source
of Matisse's curving
lines and colors spread
in flat fields.

"YOU WILL SIMPLIFY PAINTING"

"A painter exists," said Matisse, "only through his paintings." His long life played out without great upheavals.

● Henri-Emile-Benoît Matisse was born on December 31, 1869 in Le Cateau-Cambrésis, in northern France. His father was a grain merchant, his mother a former dressmaker.

● Already on his way to studying law, he discovered his vocation at twenty years of age when he was forced to bed with appendicitis and his mother gave him a box of paints as a way to pass the time. He signed his first sketches Essitam, Matisse spelled backwards.

● He studied under the symbolist painter Carrière, who expelled him from his studio when Henri, as a criticism of the master's style, shouted to his fellow students: "Open the windows, the stove is smoking!"

● In 1892 he joined the atelier of Gustave Moreau at the Ecole des Beaux-Arts. Seeing his student's efforts, Moreau exclaimed: "You will simplify painting!", intuiting that Matisse would revolutionize the use of color.

● In 1894 Matisse's daughter Marguerite was born from his relationship with Amélie Parayre, of Toulouse, his model in times when money was tight. They would marry in 1898, shortly before the birth of their other two children, Jean and Pierre.

● This was the period of his experiments with the *pointillisme* of Signac and his first exhibitions at the Salon de la Société Nationale, where he had his first success: *Luxe, calme et volupté*, inspired by a line from Baudelaire.

● Matisse began spending summers in Collioure on the Côte d'Azur with his friend Derain, with whom he discovered the strong, warm, enveloping colors of the landscape. This was the beginning of the season of the *Fauves*, the unleashing of pure color as an expression of feeling.

● In 1907 he began frequenting the Paris salon of Gertrude Stein, the writer and patron of Picasso, whom he met at the Steins' while Picasso was working on *Les Demoiselles d'Avignon*.

● In the second decade of the century, an interest in Matisse was awakened on the part of Russian collectors. Shchukin and Morosov would acquire over time 48 paintings and two drawings.

♦ THE ODALISQUES
Henri Matisse poses with a model that he would paint as an odalisque in the 1930s. He prepares the scene in his studio, draping it with richly decorative fabrics.

● He began his great trips: in 1907 to Italy, in 1911 to Russia, in 1913 to Morocco. In this same period he started his long series of odalisques.

● The world war did not touch him personally, but it wounded him spiritually. Subconsciously he adopted dark tones of green, brown, purple, black.

● In the 1920s and 1930s he was prominent in the great international exhibitions: acclaimed by Russians, he found the Americans, after an initial diffidence, to be his best buyers.

● With the outbreak of the Second World War, his wife was arrested, and his daughter Marguerite, a partisan, was deported by the Germans.

● The end of the war brought a new creative surge. Afflicted from 1941 by an intestinal disease which rendered him an invalid, Matisse overcame his suffering by working: his book *Jazz* of 1947, the decoration of the chapel of the Rosary in Vence, the apotheosis of his *papiers découpés* of 1948-50 mark this period.

● Active to the end, he died in Nice on November 3, 1954.

♦ GOURDS (1916, New York, Guggenheim Museum). Matisse's palette grows dark and gloomy. These are the tragic, grief-filled years of the First World War.

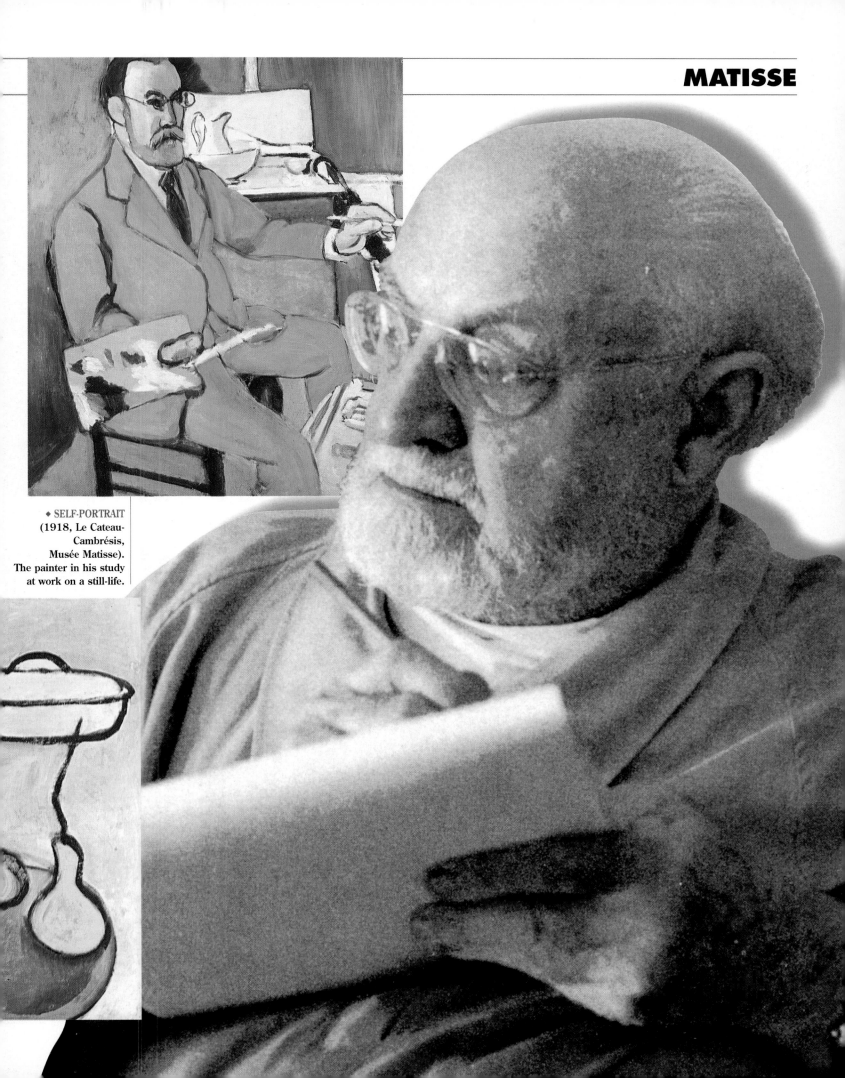

◆ SELF-PORTRAIT
(1918, Le Cateau-
Cambrésis,
Musée Matisse).
The painter in his study
at work on a still-life.

THE MAN AND THE ARTIST

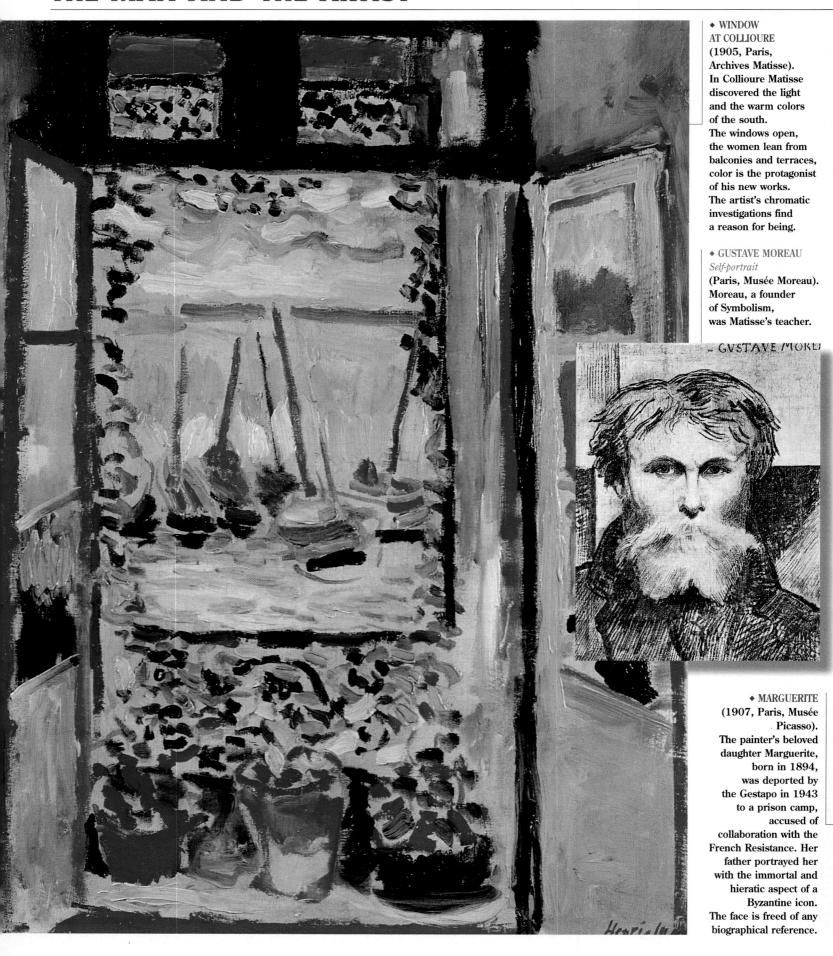

♦ WINDOW
AT COLLIOURE
(1905, Paris,
Archives Matisse).
In Collioure Matisse
discovered the light
and the warm colors
of the south.
The windows open,
the women lean from
balconies and terraces,
color is the protagonist
of his new works.
The artist's chromatic
investigations find
a reason for being.

♦ GUSTAVE MOREAU
Self-portrait
(Paris, Musée Moreau).
Moreau, a founder
of Symbolism,
was Matisse's teacher.

♦ MARGUERITE
(1907, Paris, Musée
Picasso).
The painter's beloved
daughter Marguerite,
born in 1894,
was deported by
the Gestapo in 1943
to a prison camp,
accused of
collaboration with the
French Resistance. Her
father portrayed her
with the immortal and
hieratic aspect of a
Byzantine icon.
The face is freed of any
biographical reference.

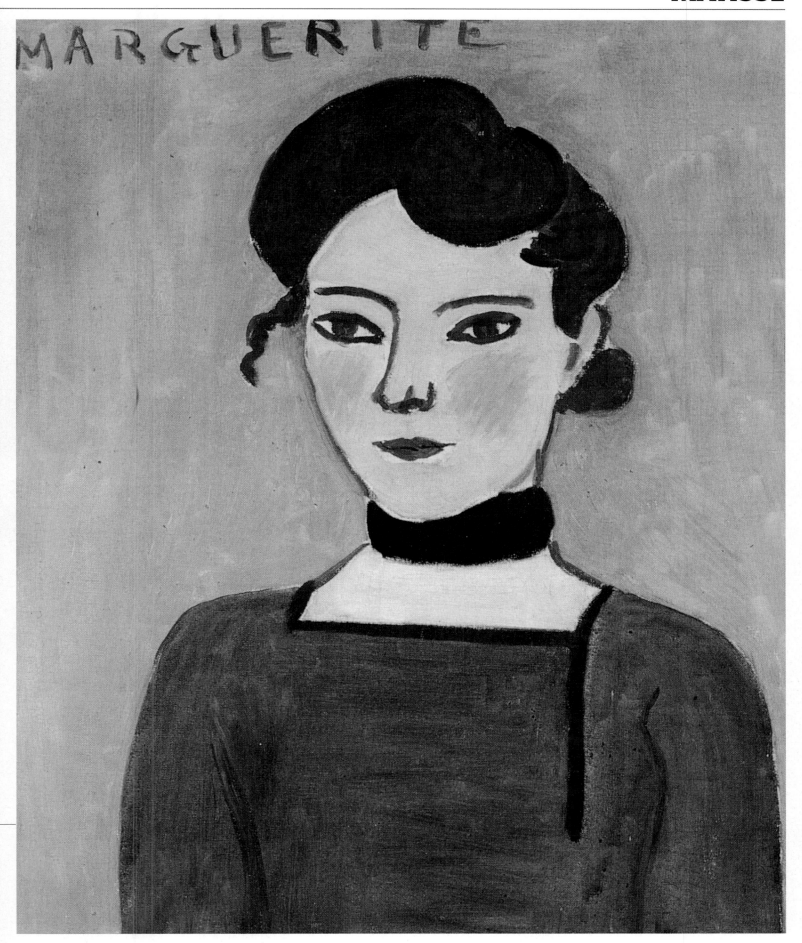

THE LONG TRADITION OF COLOR

Heir to the great tradition of French painting, Matisse in his early works measured himself against the teaching of Cézanne, the true master of the new century, the inventor of new ways of shaping form. Reinterpreting the fusion between color and compositional structure, Matisse learned from Cézanne how geometry is the foundation of anatomy and how color is built up not by chance, but can be exploited to the fullest extent of its power. He approached the study of composition following these rules.

● He very soon passed through a phase, albeit brief, of *pointillisme*, the Neo-Impressionism propounded by Signac. Between

♦ PAUL CÉZANNE
Self-portrait
(1875, St Petersburg, The Hermitage). Matisse grasped the revolution in perspective enacted by the older master, who at his death in 1906 left Matisse his studies on geometrical shapes and arbitrary colors, not assigned to objects on the basis of their appearance in reality.

♦ SELF-PORTRAIT
WITH BEARD
(1906, Copenhagen, Staatens Museum for Kunst, facing page). Matisse reveals himself to be still bound to Cézanne's teachings. He portrays himself in the same pose, seeming to adopt the same gaze and attitude. We have here the painter's earliest experiments as he searched for his own identity.

1904 and 1905, Matisse spent the summer in Saint-Tropez in Signac's circle, taking advantage of the centrifugal force of a brushstroke loaded with pure color and following the law of the harmony of contrasts. Landscapes, beach scenes, bathers in voluptuous abandon on the shore, offered him subjects for his paintings, whose colors grew increasingly intense.

● Joining expression with the colors of *pointillisme* and the plasticism absorbed from Cézanne, Matisse arrived at Fauvism. The line moved to delineate broad surfaces on the sheet, with uniform fields of color. The violence of the color enhanced the emotional charge of the painting and made visible a simple truth using a new and unusual language.

● Not understood by the public, Matisse's Fauve paintings were discovered by Gertrude Stein who brought them to the attention of the American public, thus decreeing the beginning of the artist's success.

♦ PORTRAIT OF DERAIN
(1905, London, Tate Gallery). Derain, whom he met at Carrière's school, spent the summers with Matisse in Collioure, on the Côte d'Azur. Together they discovered the new colors of the landscape and the light of the south. As in LA MOULADE (1905, private collection, at left), in this painting Matisse uses strong hues, spreading them pure on the canvas, disconcerting the public.

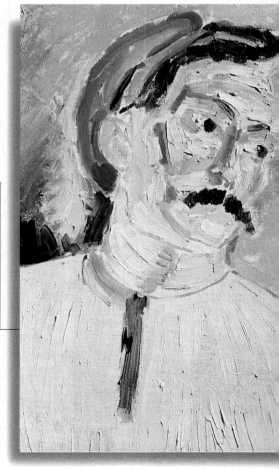

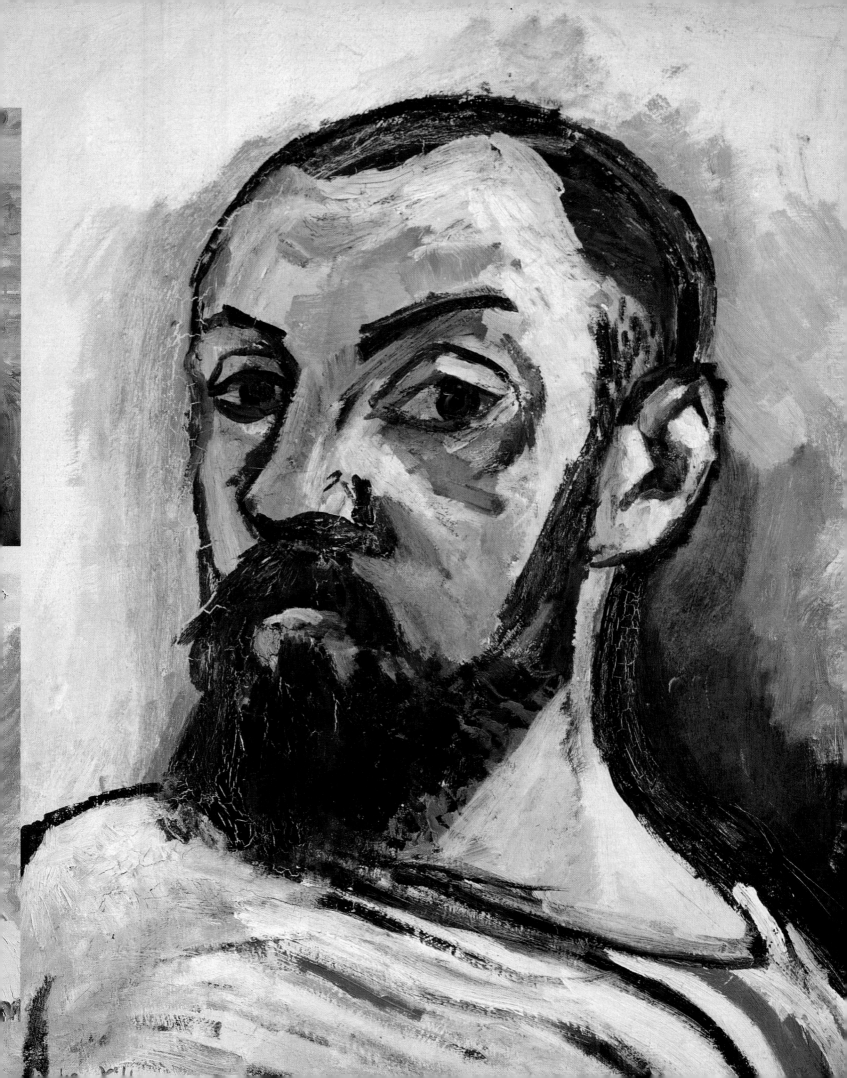

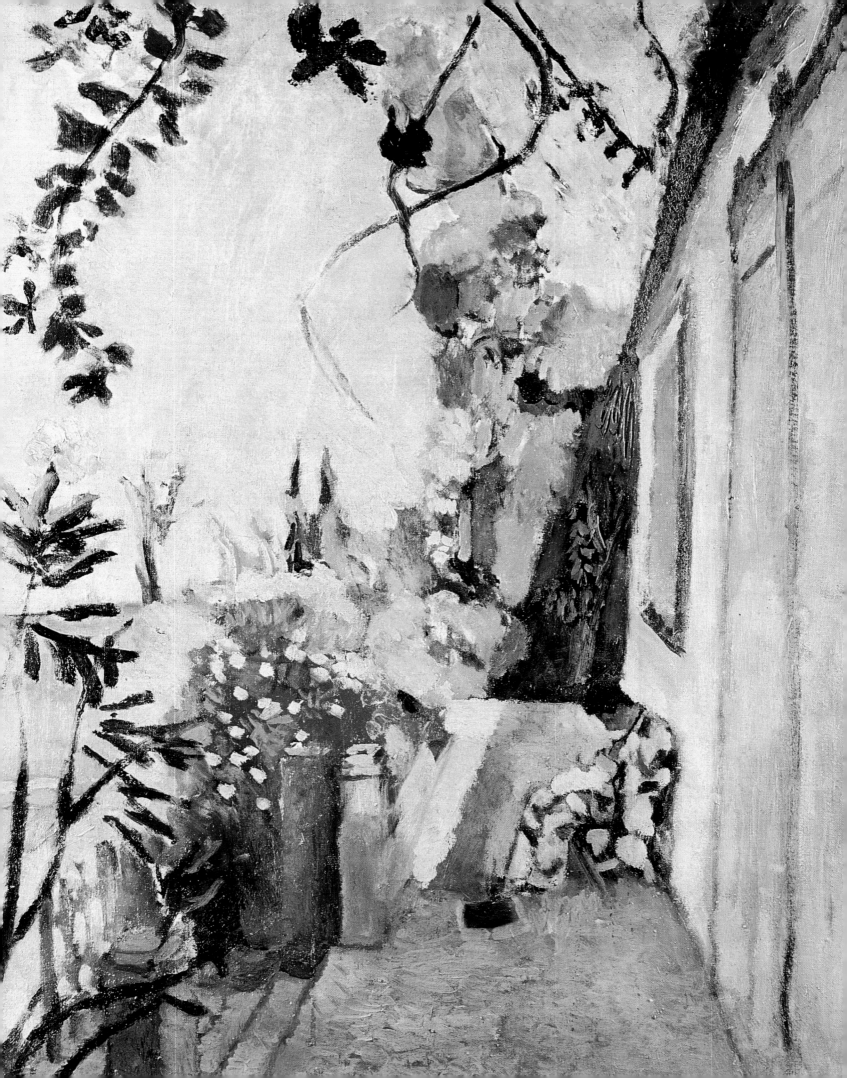

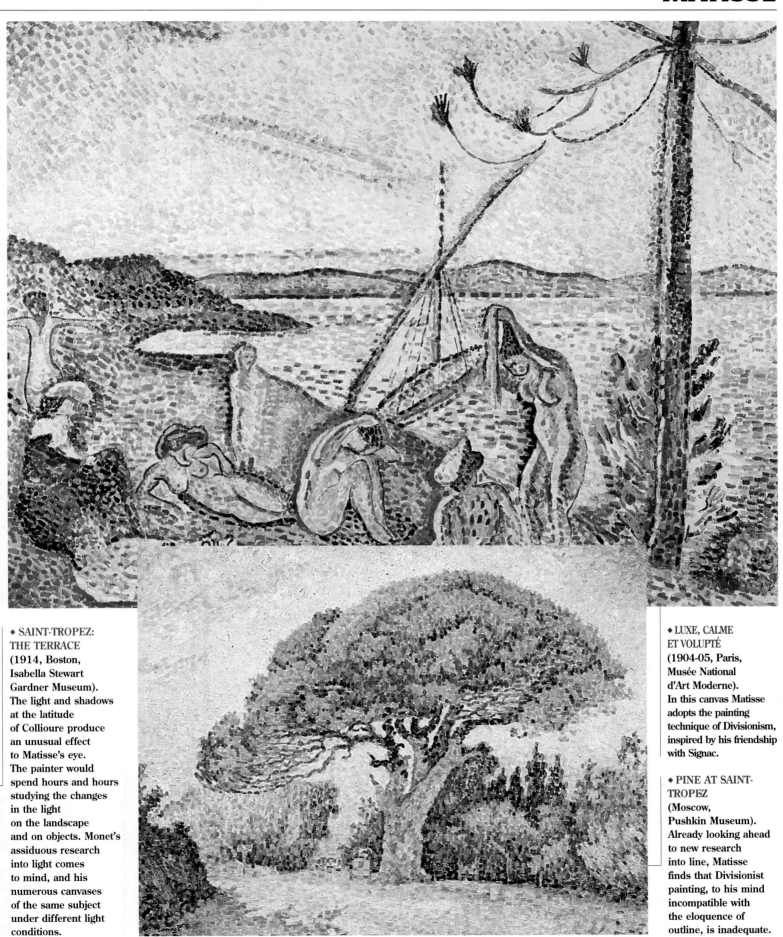

◆ SAINT-TROPEZ:
THE TERRACE
(1914, Boston,
Isabella Stewart
Gardner Museum).
The light and shadows
at the latitude
of Collioure produce
an unusual effect
to Matisse's eye.
The painter would
spend hours and hours
studying the changes
in the light
on the landscape
and on objects. Monet's
assiduous research
into light comes
to mind, and his
numerous canvases
of the same subject
under different light
conditions.

◆ LUXE, CALME
ET VOLUPTÉ
(1904-05, Paris,
Musée National
d'Art Moderne).
In this canvas Matisse
adopts the painting
technique of Divisionism,
inspired by his friendship
with Signac.

◆ PINE AT SAINT-
TROPEZ
(Moscow,
Pushkin Museum).
Already looking ahead
to new research
into line, Matisse
finds that Divisionist
painting, to his mind
incompatible with
the eloquence of
outline, is inadequate.

THE PLAY OF LINE

Line is one of the distinguishing traits of Matisse's work from the start. He immediately fell under the spell of Gauguin's Tahitian paintings – which express so well the synthesis of line and color on the canvas – and of the Nabis. The contour line was the protagonist of his art from the very beginning, along with the radiance of pure hue.

● The painter aimed at a simplification of ideas and forms, eliminating the details which compromise the purity of line and emotional intensity. The shapes created by his lines have a strong physical presence, even though only summarily sketched in. These are rapid, decisive gestures, but light and delicate at the same time. They aim at the spiritualization of the object or the human figure, transforming the substance of things into pure light.

● The play of his line is best expressed in his lithographs and monotypes, where the line is distilled to its essence. Curves and countercurves, bordering on the formless, translate into symbols the group of objects. Just a few strokes define his relationship with the object, as Matisse had observed and studied in the calligraphic force of Chinese and Japanese prints.

● Masks, arabesques, nudes, portraits, vegetable motifs are captured by the play of line which, like pure pulsation, is able to give form to the void while at the same time avoiding abstraction.

THE MONOTYPE TECHNIQUE

Monotype consists in inking a metal plate and then drawing with a stylus to remove the ink. By next applying a sheet of paper to the inked plate, an impression is obtained. Matisse utilized this technique only from 1914 to 1917, achieving the luminous force of white marks on a black ground, which express volume with the grace of a simple line.

His monotypes can be viewed in connection with the art of Persian pottery, which Henri Matisse loved and was able to admire at the Louvre. "Persian pottery," the artist told a friend, "even though monochrome, does not make us miss the abundance of color in Oriental miniatures, because the motif incised into the pieces tells us everything this country wants to communicate in that precise moment."

◆ NUDE SEEN FROM THE BACK (1916, Paris, Bibliothèque d'Art et d'Archéologie). The monotype highlights the fundamental lines of a pose from the back. Just a few lines define the warmth of a body.

◆ FERN, FRUIT AND FEMALE FIGURE (1947, private collection). In 1947 Matisse took up drawing again, working with brush and ink on paper. The technique has the same qualities as painting.

♦ SEATED NUDE WITH CROSSED LEGS (1941-42, private collection). This linoleum print is part of a large group of linocuts produced by Matisse in his efforts to purify his sign. The outline becomes protagonist, accompanying the absolute radiance of the body as it emerges from the black ground. Even though only summarily traced, the forms produced by its lines have an intense physical presence.

♦ FIG LEAVES (1941, private collection). These are among Matisse's most successful vegetable motifs. During his convalescence after his operation in 1941, the painter studied vegetable motifs, expressing his return to life in a vast production of line drawings. The contemplation of plants evokes Chinese doctrines.

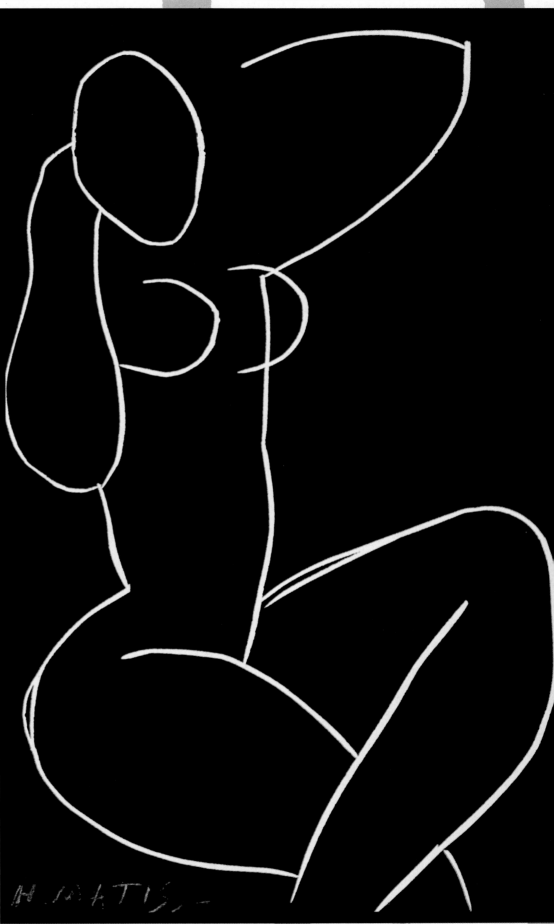

THE ODALISQUES

In December 1917 Matisse went to Nice for the first time, where he was charmed by the beauty of the colors and light and by its warm atmosphere, which reawakened the sensations he had brought back with him from Morocco. This was the beginning of his series of odalisques, more than fifty canvases on the same subject, painted from 1919 to 1949. Figures of beautiful Mediterranean women in indolent, languid poses, captured in moments of intimacy, differentiated by colors, accessories, and costume, mark the passage to a period of inner reflection for the artist, a time of release of tension after the horrors of the First World War.

● The room becomes the setting for his models; there he arranges every sort of decoration – screens, rugs, curtains – brought back from his trips to the Orient. Light represents the fundamental element, and Matisse plays with it using windows to mediate between indoors and outdoors.

● The master had a long Romantic tradition behind him of the iconography of the odalisque: Delacroix and Ingres had proposed the Oriental female figure in the way most faithful to reality, in plausible settings. Matisse gave free rein to the fruits of his fantasy, inserting the subjects into a purely theatrical stage set, as he had seen in Diaghilev's Russian ballet, *Shéhérazade*, presented in Paris in 1910.

DIAGHILEV AND THE RUSSIAN BALLET

Sergej Pavlovich Diaghilev (1872-1929) founded the celebrated "Ballets russes" in 1909, breaking with the formalism of classical choreography and unifiying music, dance, and design. From 1890 to 1905 Diaghilev lived in St Petersburg, where he founded the magazine *Mir Iskusstva* (The Art World). In 1906 he arrived in Paris and organized at the Salon d'Autômne the largest show of Russian art ever seen in the West. Matisse was fascinated, appreciating especially the religious icons. Exiled from Russia in 1914, Diaghilev settled in Paris, becoming a promoter of Russian art throughout Europe. Diaghilev also staged the new Russian ballet, with Bakst's choreography which would revolutionize European theater.
Artists like Braque, Picasso, and Rouault worked on stage sets for Diaghilev's ballets. Matisse created for him the scenes for the *Chant du Rossignol*.
Publisher, impresario, talent scout, Diaghilev also created a company of young dancers, the Vaslav Nijinskij.

MY MODELS

In 1939, Matisse wrote of his models Dina, Hélène, Lydia, and Paula:
"They are never simple supernumeraries in an interior. They are the main theme of my work. I depend absolutely on my models. In the beginning I observe them freely, and only after that do I decide to fix on the canvas the pose which corresponds best to their 'nature.' When I take a new model, it is from the position she assumes at rest that I intuit the pose which suits her best and to which I become a slave."
Women languidly reclining, seated, or standing, in richly decorated interiors, abandon themselves defenseless to the painter's eye, as he masterfully captures their forms, the sensuality they emanate, their passion, sighs, smells. Among all the dark Mediterranean women, the Russian Lydia stands out.

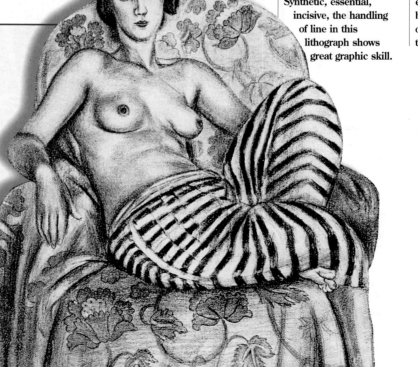

◆ LARGE ODALISQUE WEARING BAYADERE PANTS (1925, Paris, Bibliothèque d'Art). Synthetic, essential, incisive, the handling of line in this lithograph shows great graphic skill.

◆ THE RUSSIAN IMPRESARIO
Above, a period portrait of Sergej Diaghilev. Diaghilev came to Paris early in the 20th century, becoming a promoter of Russian art throughout Europe.

◆ SEATED NUDE WITH TAMBOURINE (1926, New York, Museum of Modern Art, Paley collection). Vaguely Cubist connotations mark this odalisque seated in the foreground. The room becomes a backdrop for the model; Matisse enriches it with the most varied decorations: screens, rugs, curtains, objects which he brought back with him from his trips to the Orient.

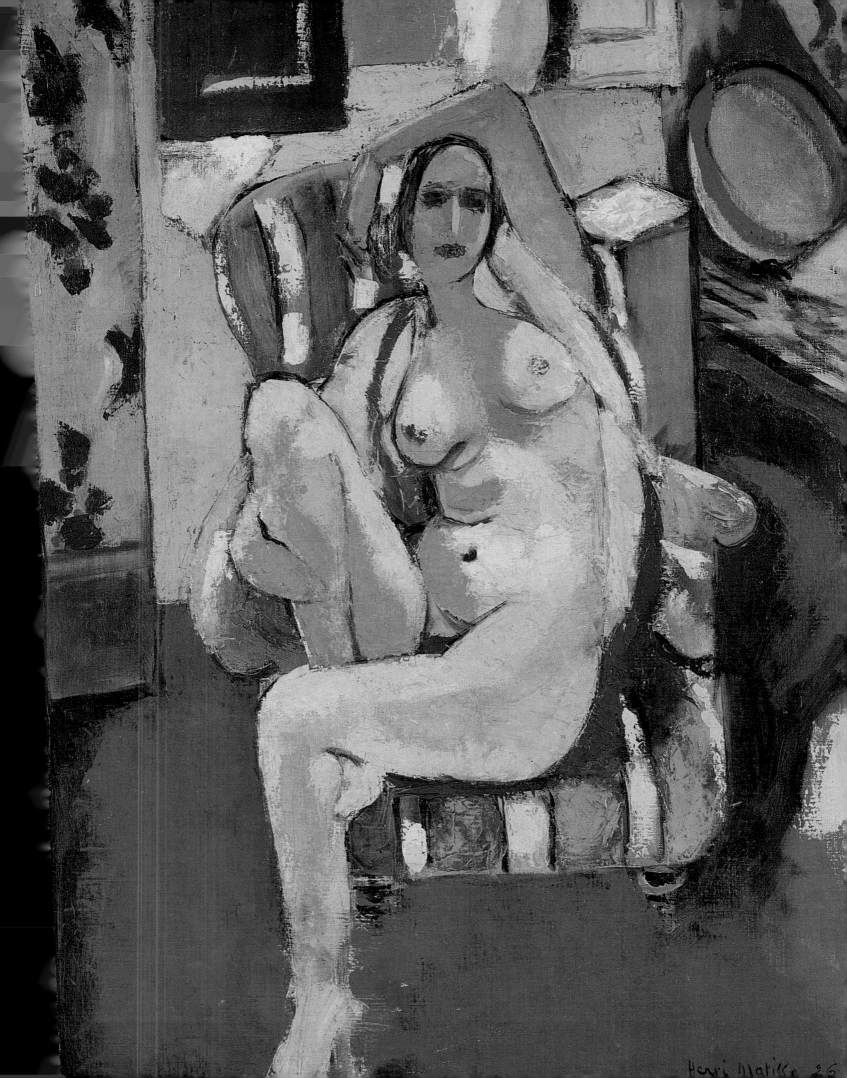

PRODUCTION: THE PURITY OF THE LINE

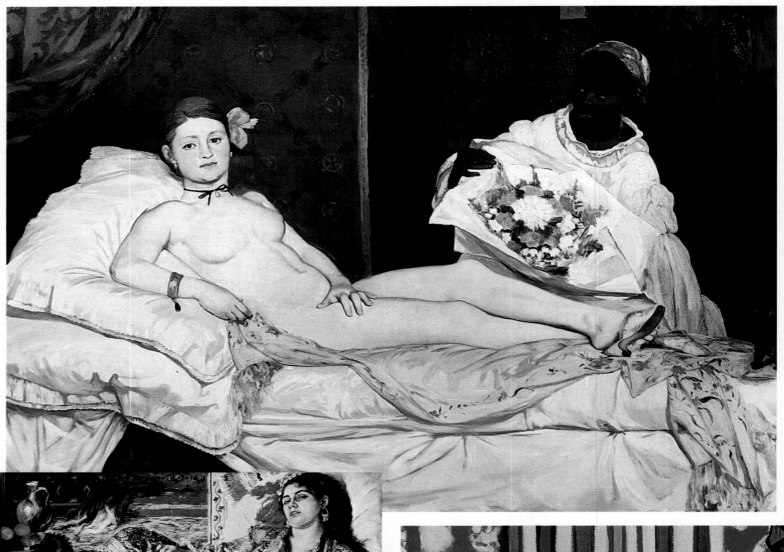

◆ EDOUARD MANET
Olympia
(1863, Paris,
Musée d'Orsay, above).
Manet as well
approached the theme
of the female nude in
an interior, but in
a pudic, sedate pose,
classically pure in form.
There is nothing to
excess in her pose, and
Olympia calls to mind
the measured beauty
of Canova's Paolina
Borghese. Manet here
studies the effects of
light on white sheets.

◆ AUGUSTE RENOIR
The Odalisque
(1870, Washington,
National Gallery of Art).
The subject takes
her place in the
Orientalizing current
of Romanticism.
In a deliberately languid
pose, the woman offers
herself up to the viewer,
immersed in the
decoratively ostentatious
setting. Inspired
by Delacroix, Renoir
revisited exotic places,
traveling in 1881
to northern Africa.

◆ ODALISQUE
WEARING GRAY PANTS
(1927, Paris,
Musée de l'Orangerie).
The subject's pose
changes again. Matisse
declared that he was
absolutely dependent
on his model: he would
observe her for hours,
leaving her completely
free, in order to capture
her most natural
and hidden gestures.
Only after this would
he decide which one
to immortalize
on the canvas.

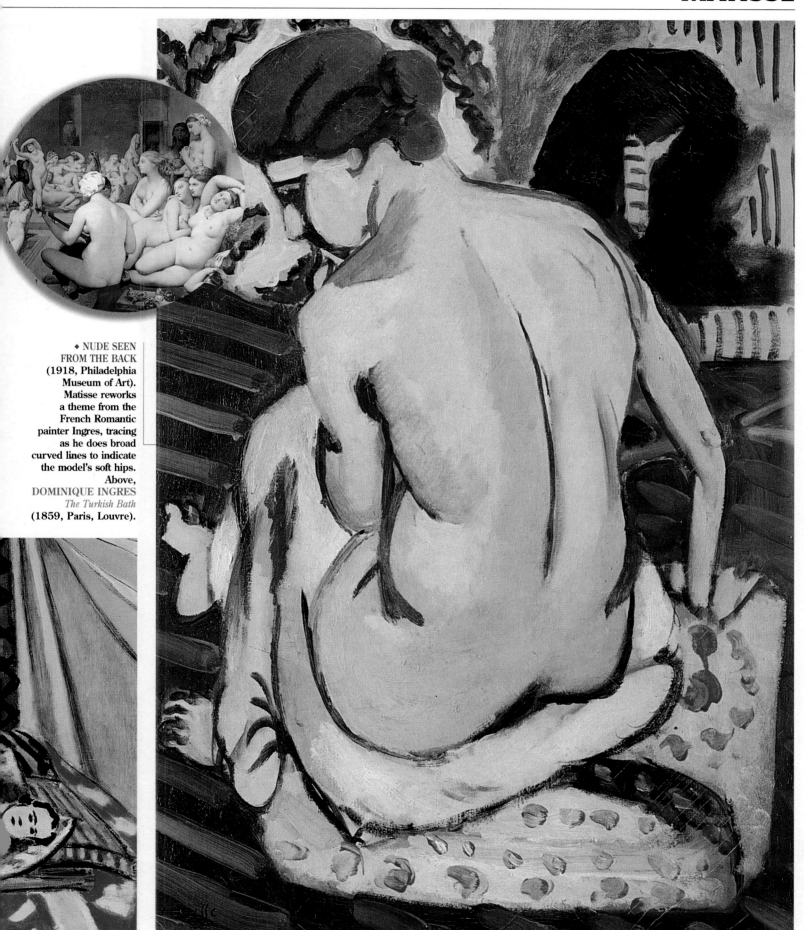

♦ NUDE SEEN FROM THE BACK (1918, Philadelphia Museum of Art). Matisse reworks a theme from the French Romantic painter Ingres, tracing as he does broad curved lines to indicate the model's soft hips. Above, DOMINIQUE INGRES *The Turkish Bath* (1859, Paris, Louvre).

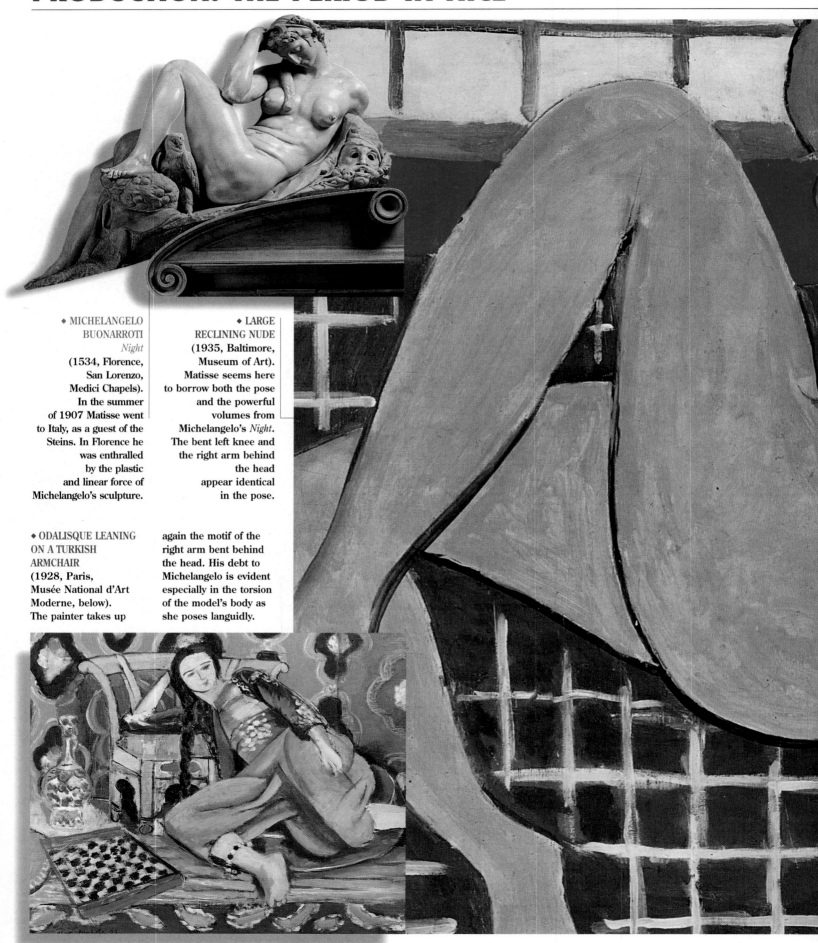

◆ MICHELANGELO
BUONARROTI
Night
(1534, Florence,
San Lorenzo,
Medici Chapels).
In the summer
of 1907 Matisse went
to Italy, as a guest of the
Steins. In Florence he
was enthralled
by the plastic
and linear force of
Michelangelo's sculpture.

◆ LARGE
RECLINING NUDE
(1935, Baltimore,
Museum of Art).
Matisse seems here
to borrow both the pose
and the powerful
volumes from
Michelangelo's *Night*.
The bent left knee and
the right arm behind
the head
appear identical
in the pose.

◆ ODALISQUE LEANING
ON A TURKISH
ARMCHAIR
(1928, Paris,
Musée National d'Art
Moderne, below).
The painter takes up

again the motif of the
right arm bent behind
the head. His debt to
Michelangelo is evident
especially in the torsion
of the model's body as
she poses languidly.

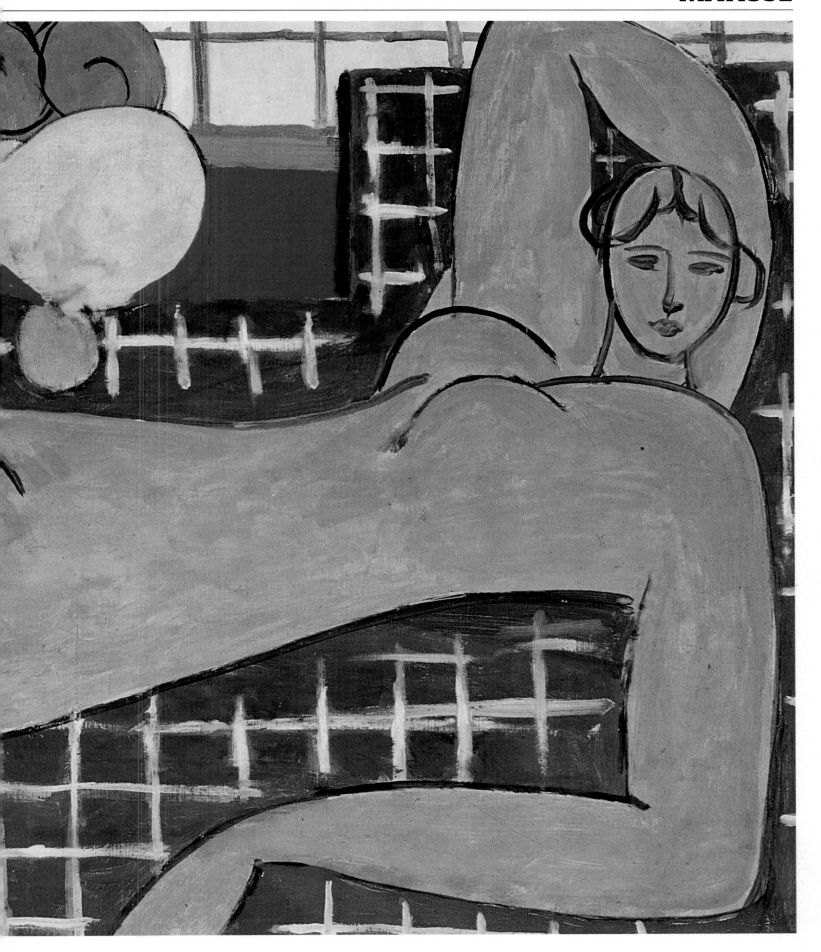

THE FACE DISAPPEARS

Faceless figures are one of the most readily noticed characteristics of Matisse's style. The first appearance, or better, disappearance of the facial features dates to 1906, with *The Joy of Life*, and recurs throughout his entire career.

● The motif of the empty face can be linked to the Eastern influence on Matisse's work. Fascinated by the iconoclastic dimension of Byzantine and Russian icons, which limit representation of physiognomy to stereotyped features, he emphasized the decorative element and the use of color, to the detriment of the identity of the sitter. Matisse thus approached here Islamic art, which is more drastic in abolishing the human presence and completely covering the available surface with abstract pattern.

◆ THE JOY OF LIFE (1906, Merion, Barnes Foundation). The theme of humankind happily inserted into nature had already been treated in *Luxe, calme et volupté*, of 1904, as concrete carnality. In the background Matisse puts the rhythmic motif of a ring dance, anticipating what he would do with *La Danse* in 1910.

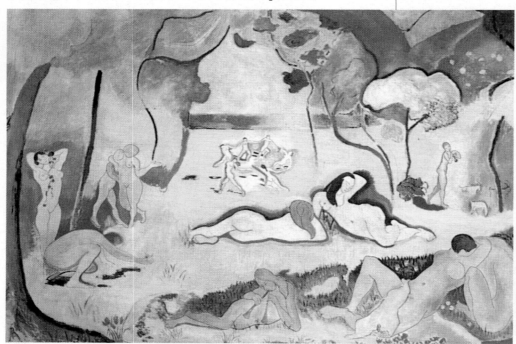

● Elimination of facial features is taken to its extreme in the *papiers decoupés*, paper cutouts painted with tempera, in which the essence of the figure represented is entrusted to the contour line. In the Chapel of the Rosary at Vence, as well, the protagonists of the Passion have empty faces. The story is told that the parish priest of Vence asked Matisse if, working for peasants, he would have drawn the eyes and mouth. "Yes, certainly," the artist is said to have replied, "but it would not have been as expressive."

◆ PORTRAIT OF AUGUSTE PELLERIN II (1917, Paris, Centre Georges Pompidou, upper left). Here Matisse takes up the stylized physiognomy and frontality typical of Eastern icons, like the one shown here at lower left: NOVGOROD SCHOOL *St Nicholas* (late 13th century).

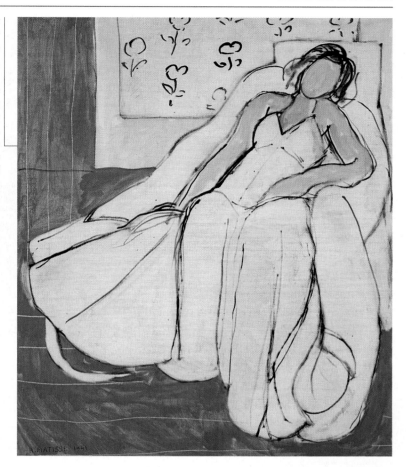

◆ GIRL DRESSED
IN WHITE AGAINST
A RED BACKGROUND
(1944,
private collection).
The syntax of the face
is subordinated here
to broad fields of pure
color, which expand
beyond the picture
plane. The "fullness
of the void" of
the figure provides
a formal solution
for the study
of color, in which
Matisse intuits
the possibilities
of his *gouaches découpées*
of later years.

◆ NUDE WITH
SPANISH RUG
(1919,
private collection).
This painting marks
the beginning of the
series of the *visages vides*
(empty faces), one
of the best known
stylistic elements
of Matisse's painting.
The facial features
disappear, following
the custom of Islamic
art. Individuality is set
aside, giving greater
value to the decorative
aspect and the use
of color. Matisse does
not fail to include
a rich ornamentation
of the setting.

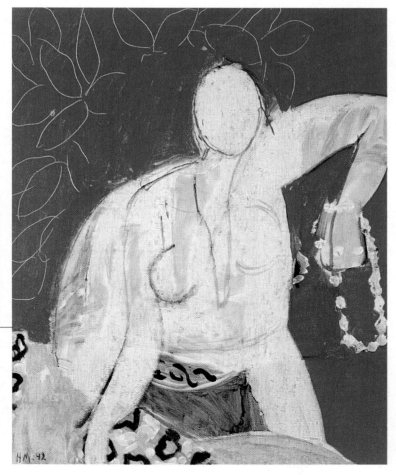

◆ YOUNG WOMAN WITH
A PEARL NECKLACE
(1942,
private collection).
Another painting
in the series of *visages
vides*, this canvas
stands out for its
powerful use
of red, enveloping like
a cloak the female
figure which is just
barely sketched in.
Matisse hints
at a vegetable motif
engraved into this wall
of color, which seems
to arrange itself
like a crown around
the model's head.

TWO MASTERPIECES TO CONQUER ILLNESS

From 1941 on, Matisse was confined to a wheelchair after the removal of a tumor from his intestine. Having to cut down on physical activity, he turned to publishing, illustrating literary texts. By 1935 he had made six engravings for James Joyce's *Ulysses* and 52 engravings to accompany Mallarmé's poetry. But it was in 1944, with his illustrations for *Pasiphae* by Henri de Montherlant that his graphic work in this vein reached maturity.

● In 1947 the Tériade publishing house issued *Jazz*, a masterwork containing twenty lithographs with a text of poetry by the artist. This was the beginning of a new expressive technique: Matisse gathered together sheets of paper covered with tempera and cut them out to form figures. These were his *papiers découpés*, the ultimate fusion of light and color, apotheosis of his technique of applying the paint *à plats*, the explosion of large patches of pure color, a two-dimensional synthesis dearest to the artist. Form and color become the absolute protagonists of a musical universe in which contrast is the play of harmony.

● From 1948 to 1951 Matisse accomplished his last work, started almost as a game: the *ex voto* of an atheist who wanted to thank the nursing nuns in the hospital where he had undergone his operation. A stranger to every form of religious faith, he measured himself against the story of the Resurrection. He knew nothing of the Catholicism, but he interpreted the drama of Christ's suffering as the personal experience of his human pain. He thus created, through the use of an essential but vibrant design, a decoration made up of simple elements: profiles, colors, surfaces

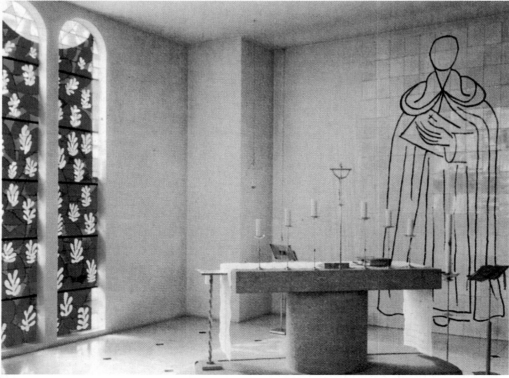

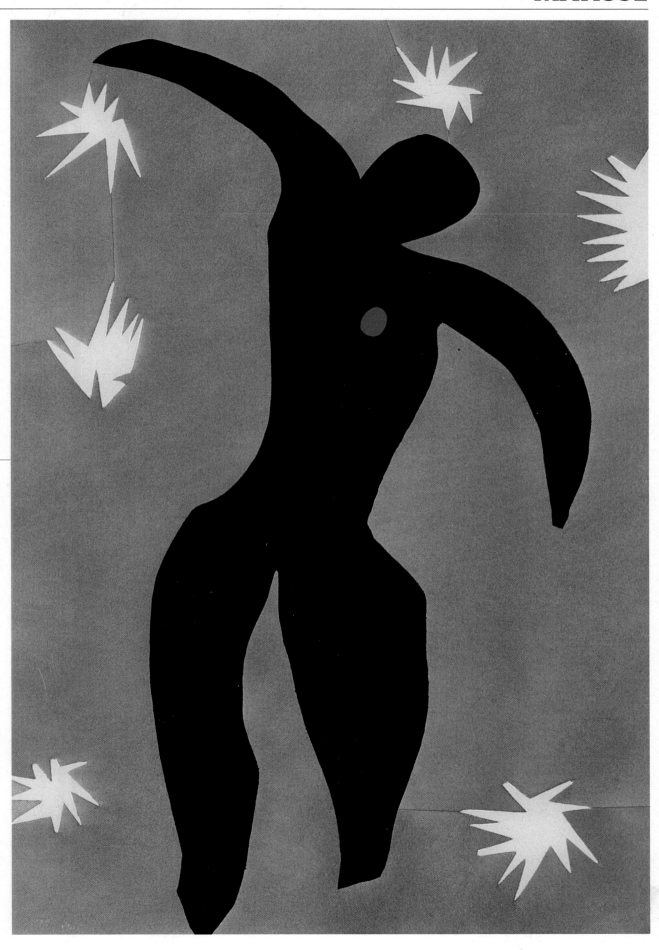

◆ HIS NEW
PRODUCTION
In 1942 Matisse
announced to his art
dealer Paul Rosenberg
that he would do
everything he could
to go back to painting.
After devoting his
efforts to drawing,
which during his
convalescence was less
demanding physically,
the master turned again
to color. The return of
his illness coincided
with the birth of
the *papiers découpés*.

◆ THE FLIGHT
OF ICARUS
(1947, Paris,
Musée d'Art Moderne,
from *Jazz*).
Twenty lithographs
accompanied by a text
of poetry make up *Jazz*,
Matisse's book
published by Tériade
in 1947. He created
a new technique for
expression: the master
took paper painted with
tempera and cut it out
to form figures. These
are the *papiers découpés*,
the ultimate fusion
of light and color.
Forms and hues dance
in the composition,
by now its sole
protagonists.

◆ THE TREE OF LIFE
From 1948 to 1951,
Matisse devoted his
efforts to the decoration
of the Chapel of the
Rosary at Vence.
At the beginning, almost
as a game, he wanted to
create a secular *ex voto*,
to thank the Dominican
nuns who took care
of him in the hospital.
The Tree of Life
comprises the two
panels of stained glass
windows in the chapel
apse. Before reaching
this solution,
the artist worked
on two projects which
he then abandoned.

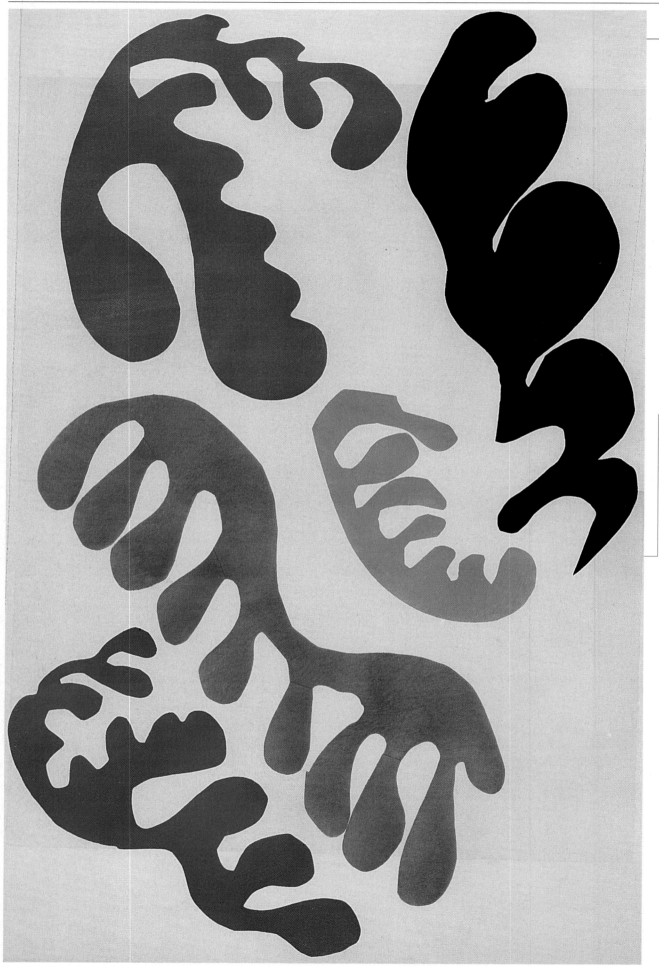

◆ THE WOLF
(1947, Paris,
Musée d'Art Moderne,
from *Jazz*).
"Instead of drawing the
outline and then filling
in the color – the two
elements capable of
modifying each other –
I draw directly with
color," Matisse said
in 1951. He had found
a technique which
allowed him to unite
once again line and
hue. Now he would be
able to work on
the great decorations
for the Chapel at Vence,
even though confined
to a wheelchair.

◆ THE LAGOON
(1947, Paris,
Musée d'Art Moderne,
from *Jazz*).
The forms, which
earlier were figurative,
now leave behind
the universe of the real
to move into an abstract
one. Free splashes
of color float in the air,
in the music. Just as
Matisse conceived
the color in his mind,
his *papiers découpés*
allowed him to create
it with his hands.
He found this technique
exciting: the artist
would declare he had
never felt so balanced.

◆ THE CLOWN
(1947, Paris,
Musée d'Art Moderne,
from *Jazz*).
The *papiers découpés*
technique uses
sheets of painted paper,
cut in the forms
desired. At lower right,
MONSIEUR LOYAL
(1947, Paris,
Musée d'Art Moderne,
from *Jazz*).

34

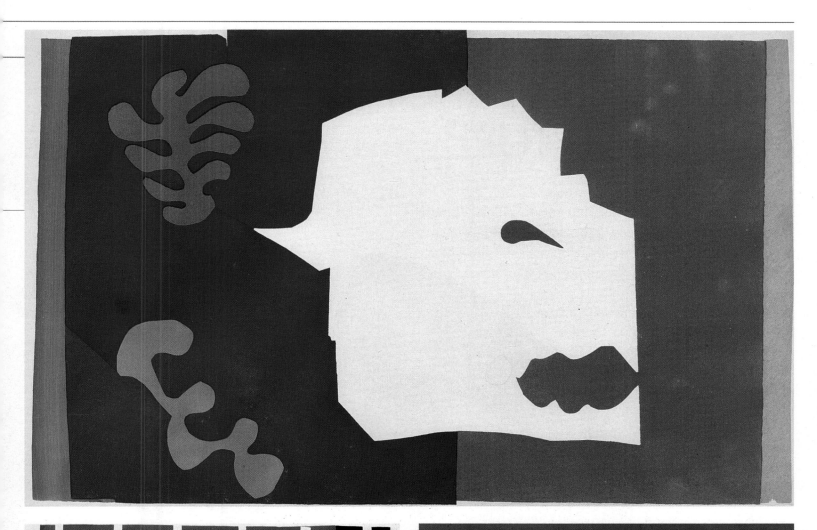

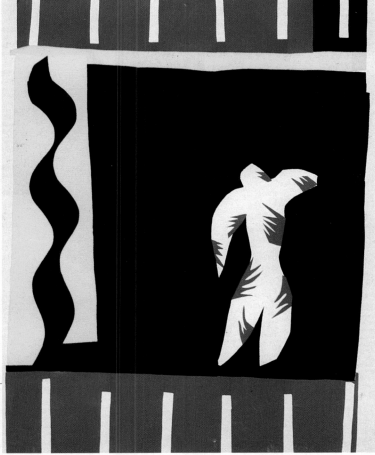

TRIBAL INSPIRATION FOR SCULPTURE

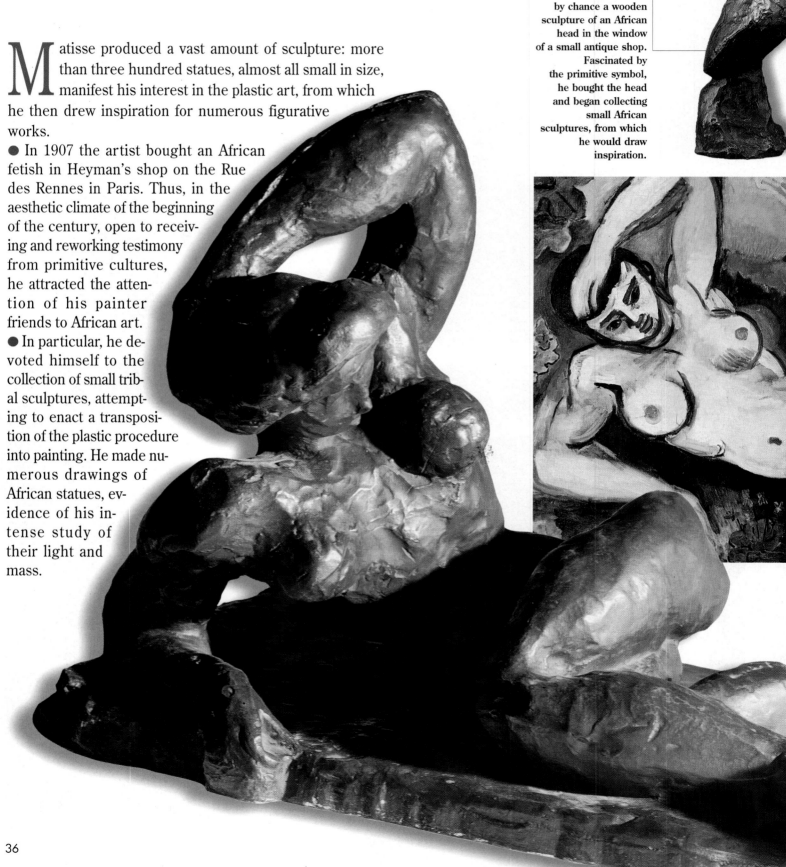

Matisse produced a vast amount of sculpture: more than three hundred statues, almost all small in size, manifest his interest in the plastic art, from which he then drew inspiration for numerous figurative works.

● In 1907 the artist bought an African fetish in Heyman's shop on the Rue des Rennes in Paris. Thus, in the aesthetic climate of the beginning of the century, open to receiving and reworking testimony from primitive cultures, he attracted the attention of his painter friends to African art.

● In particular, he devoted himself to the collection of small tribal sculptures, attempting to enact a transposition of the plastic procedure into painting. He made numerous drawings of African statues, evidence of his intense study of their light and mass.

◆ JEANNETTE V (1916, Toronto, Art Gallery of Ontario). In 1906 Matisse discovered African art. In Paris, on the Rue des Fleures, he noticed by chance a wooden sculpture of an African head in the window of a small antique shop. Fascinated by the primitive symbol, he bought the head and began collecting small African sculptures, from which he would draw inspiration.

◆ SEATED FIGURE FROM MALI
At the Steins' house, Matisse showed Picasso the statue he had bought. Together they studied its dimensions and lines. Here to the right is an African statuette from Matisse's collection, from which he took inspiration for the bronze on the left. The master was fascinated above all by the profile, with its determined and strongly plastic line.

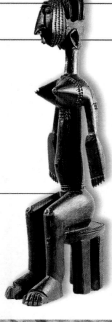

◆ MADAME MATISSE (1912-13, St Petersburg, The Hermitage). Matisse made numerous portraits of his wife. In this painting, he makes explicit reference to the tribal art of African masks, which he had admired in the Ethnological Museum of the Trocadéro in Paris and collected with great passion. Her facial features appear stylized.

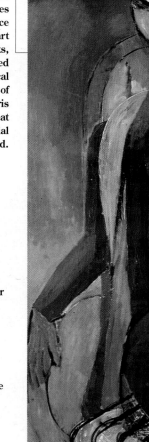

◆ BLUE NUDE (1907, Baltimore, Museum of Art). Matisse made a transposition from sculpture to painting. First he created the bronze here below, working with the power of the mass and the fullness of form, and then tried to transmit the same characteristics into his painting. What struck him in primitive African sculpture was the building up of the form by invented planes.

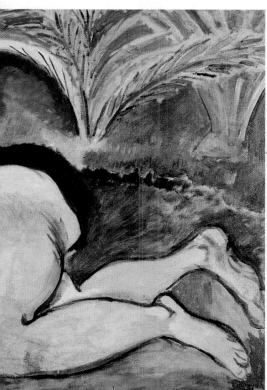

◆ FANG MASK
This mask from Gabon inspired the facial features for the portrait of Madame Matisse. Notice the arch of the eyebrows and the lines of the nose.

◆ RECLINING NUDE (1907, New York, Museum of Modern Art).

◆ RELIQUARY FIGURE FROM GABON
The primitive aspect of African art is evidenced in the emphasis on decorative synthesis and the two-dimensional archaic style.

AFRICAN SCULPTURE

African sculpture reached Paris with the opening in 1898 of the Ethnographical Museum at the Trocadéro and captivated the artists for the energetic force of synthesis which distinguishes the modeling of the masks and fetishes. African sculpture presents itself to the viewer as stripped down, simplified to the utmost, almost graphic in style: narration is reduced to its essential terms. The two great modern "primitives," Gaugin and Cézanne, were the first to intuit the primeval vitality of the formal construction of an exotic art. Cubism, German Expressionism, Italian Futurism and French Fauvism all looked to African sculpture in their search for perspective solutions different from conventional ones.

THROUGH TWO WORLD WARS

Matisse was born during a time of great political change in Europe; in 1870 the Kingdom of Italy was proclaimed, and in 1871 Germany was formed out of what was left of the great Prussian empire. In the meantime the new generation of French painters was preparing the first Impressionist exhibition, and in 1874 the photographer Nadar showed pictures by Monet and his circle in his Paris atelier in Rue des Capucines.

● The young Henri began painting in 1890, during his convalescence after a brief illness, while Oscar Wilde published *The Portrait of Dorian Gray*, and Vincent van Gogh shot himself in the head, dying after an agony lasting three days.

● In 1899 Marconi invented the wireless telegraph, for which he would win the Nobel Prize ten years later.

● England's Queen Victoria died while Matisse was showing for the first time at the Salon des Indépendants; this was 1901, the beginning of the new century. Freud was upsetting society with his new theories of psychoanalysis; the Wright brothers

♦ THE ACCURSED POET
Oscar Wilde, Victorian England's most disturbing writer.

made their first flight, and Einstein worked on the theory of relativity.

● In 1905 Matisse and his friends Derain, Marquet, and Vlaminck were christened the "Fauves," wild beasts, for their paintings shown at the Salon d'Autômne, while Picasso was painting in his "pink period" and Franz Léhar was dedicating to Vienna his operetta *The Merry Widow*, an expression of the decadent world of the end of the Austro-Hungarian empire.

● In Europe, signals of rupture were being felt: the Balkans were in ferment, and nationalistic claims were a growing threat. In 1914 at Sarajevo, the archduke Franz Ferdinand of Austria, heir to the throne, was assassinated, and the First World War began. Matisse, exempted from military service, left for Collioure with his family, spending the war years there. With the return of peace, Paul Guillaume's gallery in Paris was the venue for an exhibition by Matisse and Picasso.

● In the early 1920s the great political forces regrouped: in France the Communist Party was born, Mussolini marched on Rome in

♦ THE GREAT SOUL
Above, a photo of Mahatma Gandhi, the Indian leader of non-violence, assassinated in 1948.

♦ THE MARCH OF FASCISM
Left, Mussolini's march on Rome in 1922.

1922 and set up his first government. A young Austrian with artistic aspirations, Adolph Hitler, attempted a *coup d'état* in Germany in 1923.

● In 1929, the year of the collapse of the New York stock market, Matisse traveled to the United States, where he was awarded the Carnegie International Exhibition Prize.

● In 1941 he underwent an operation in Lyon for an intestinal tumor. These were the years of the Second World War; France had been invaded by Germany the year before, all the European forces had by now taken their positions, and after the Japanese attack on Pearl Harbor, the United States came into the war on the side of the Allies.

● By now confined to a wheelchair, the artist devoted himself to illustrating

◆ PABLO PICASSO
Self-portrait
(1907, Prague, Narodni Galerie). Matisse met the Spanish artist in the Steins' salon; they were patrons and promoters of the aesthetic of the two painters.

◆ THE ITALIAN NOBEL PRIZE WINNER
1899; Marconi created the wireless telegraph, which in a few short years would revolutionize the field of communications. For his invention, he received the Nobel Prize in 1909.

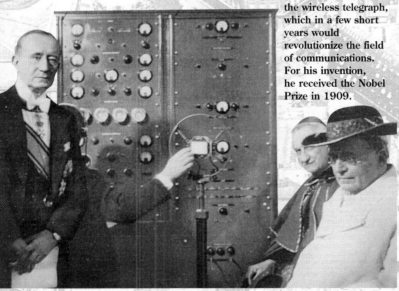

books; in 1947, while the Marshall Plan was attempting to rebuild a Europe in shambles, Tériade published *Jazz*.

● From 1948 to 1951 Matisse worked on the decorations for the Chapel at Vence, won a prize at the XXV Biennale in Venice, and read in the newspapers of Gandhi's assassination in India and of the creation of the new state of Israel. In 1953 Stalin died and Russia worked at re-evaluating his work. In the meantime, in France, Matisse encountered great success with his exhibition of the *papiers découpés*.

● In 1954 France lost Vietnam and Algeria, the jewels of its colonialist campaign of the preceding century. On November 3, she lost also, at the age of 84, Henri-Benoit Matisse, one of her greatest artists.

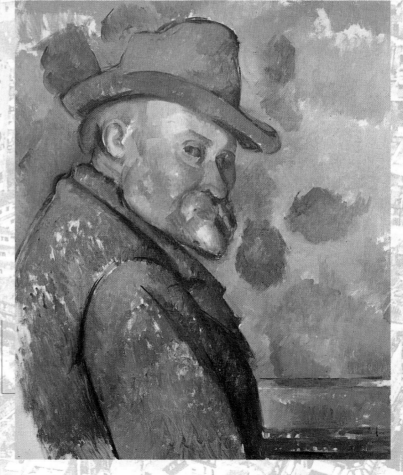

◆ CEZANNE
Self-portrait Wearing a Hat
Cézanne revolutionized the new century's way of looking at perspective. Matisse declared on numerous occasions that he owed a great deal to his teaching. He died in 1906.

THE TRIUMPH OF THE SYMBOL

"Matisse has left me his odalisques in heredity," Picasso declared at the news of the artist's death in 1954. The French artist's curving, voluptuous female forms and deep Mediterranean eyes had fascinated the Spanish artist for more than thirty years.

● The *corpus* of work which Matisse left behind him is among the richest in the history of art: a thousand pictures, 300 sculptures, more than two thousand drawings, gouaches, engravings. He worked unceasingly, without idle periods, untiring despite his illness, always in search of new aesthetic solutions.

● His solutions prefigure the characteristics of the importance

◆ ELLSWORTH KELLY *Green, Blue, Red* (1964, New York, Whitney Museum). The artist continues Matisse's studies of color, working on scientific demonstrations of the process of visual perception.

of the act itself of painting, the symbol, the play of line, which distinguished American Art Informel of the 1950s and 1960s. Artists like Ellsworth Kelly, Hans Hofmann, Barnett Newmann, Arshile Gorky adopted as their own Matisse's expressiveness of color and took the value of the symbol to its extremes with impetuous, automatic gestures. The brushstroke grows broader, color is projected outside the painting; the structure of his symbols is stamped on the canvas like the painter's own private writing. This was the triumph of the symbol, of line, of color. The triumph of Matisse's *papiers découpés*.

● Rothko too, like Matisse, left his artistic testament in his work in the Rothko Chapel in Houston, Texas, trying to find the natural symbiosis between his painting and architectural space.

◆ BLUE NUDE III
(1952, Paris,
Musée National d'Art
Moderne).
Made using the *papiers
découpés* technique, this
is one of the principal
fountainheads
of American art of
the 1950s and 1960s.

◆ MORRIS LOUIS
Gamma Delta
(1959, New York,
Whitney Museum).
Louis uses color for
its expressive qualities,
working on broad flat
surfaces.

◆ BARNETT NEWMANN
Vir Heroicus Sublimis
(1950-51,
New York, Museum
of Modern Art).
The work is a uniform
stretch of pure color.
Its size is enormous:
2.42 x 5.41 meters.

◆ MARK ROTHKO
Red and Blue on Red
(1959, Varese,
Panza di Biumo
collection).
Rothko experiments
with new volumes
achieved using color. A
study of the late work of
Matisse is fundamental
for all these artists.

THE ARTISTIC JOURNEY

For a vision of the whole of Matisse's production,
we have compiled a chronological summary of his principal works

◆ NUDE MAN (1900)

In his early works Matisse shows that he had learned the lesson of Cézanne, the master who inaugurated the new century by revolutionizing the laws of perspective. The painting, now in the Museum of Modern Art in New York, is an academic study, in which the use of color is arbitrary, already Matissian, while the forms and perspective still hark back to Cézanne's structures.

◆ DISHES AND FRUIT (1901)

Now in the Hermitage in St Petersburg, this still life vaunts a bright palette, influenced by Matisse's stay in Corsica in 1898. In renouncing details and nuances, the painter is now pursuing a new aim: decoration. He uses color in an unusual way, taking his inspiration from prints by Japanese masters.

◆ LUXE, CALME ET VOLUPTÉ (1904-05)

The picture, now in Paris in the Musée d'Orsay, was painted by Matisse using the Divisionist technique, inspired by Signac, who in September would enthusiastically purchase the canvas. Incompatible with the eloquence of the outline, Divisionism would later reveal itself to be technically inadequate for Matisse, who was pursuing new research into the possibilities of line.

◆ PORTRAIT OF DERAIN (1905)

Matisse met Derain in the studio of the painter Carrière, and together they began spending summers in Collioure, on the Côte d'Azur. The discovery of the colors and light dominating that landscape would prove crucial to the subsequent development of their art. Strong, warm, embracing colors denote the psychological nature of this portrait, now in the Tate Gallery in London.

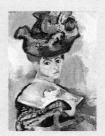

◆ WOMAN WITH A HAT (1905)

Exhibited at the Salon d'Automne in 1905, when the nickname of "Fauves," wild beasts, was first applied to Matisse and his fellow painters, this picture, now in the Museum of Modern Art in San Francisco, offers itself as a block of light, created by the studied juxtaposition of broad fields of color. Traditional modeling has been left behind and color totally dominates the space.

◆ THE ROOFS OF COLLIOURE (1905)

A town on the Côte d'Azur, Collioure was the site of numerous stays by Matisse and his fellow Fauves. The dazzling light and bright colors of its landscape determine the choices made by the proponents of the new French Expressionist painting. The picture, today in the Hermitage in St Petersburg, refers to Cézanne not only for its compositional structure but also for its formal solutions.

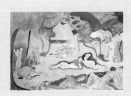

◆ THE JOY OF LIFE (1906)

The motif of humankind inserted into a luxuriant nature, the intimate enjoyment of spirit and the senses, had already been treated in the earlier *Luxe, calme et volupté* as the expression of a real carnal identity. In the background Matisse already puts the motif of the ring dance, anticipating the theme of the later *La Danse* painted in 1910. The painting is the property of the Barnes Foundation in Merion, Pennsylvania.

◆ WOMAN ON A TERRACE (1906)

Painted in Collioure, this picture, now in the Hermitage in St Petersburg, emphasizes a broad use of contour lines, traced deliberately in different colors from the fields of color that they delineate. Matisse plays with color and volume, taking as his starting point a theme frequently recurring in his production: a woman portrayed on a terrace or on the threshold of a French door.

◆ VASES AND FRUIT ON A RED AND BLACK RUG (1906)

Matisse painted a large number of still lifes, in a constant search for new color combinations and a direct contact with the decorative element. Picture after picture, the still life becomes more alive than the subject, its existence is perceived almost physically. The artist brought back with him from Algeria rugs, fabrics, and ceramic knicknacks purchased in bazaars and used them in his paintings.

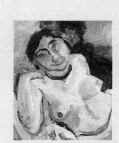

◆ THE GYPSY (1906)

With this *Gypsy*, now in the Musée de l'Annonciade in Saint-Tropez, Matisse approached German Expressionist painting, which used violent, dramatically expressive colors and forms. His intention, however, remained rigorously painterly: he wanted to experiment with new ways of using color, far distant from the ideological motives which nourished the movement in Germany.

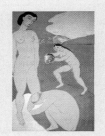

◆ LUXE II (1907)

On the threshold of forty, Matisse took refuge in an Eden in the midst of nature. Pure colors, spread in broad patches, the play of curved lines articulating the compositional structure of the picture, and soft, voluptuous bodies mark this second version of *Luxe*, now in the Staatens Museum for Kunst in Copenhagen. The other version is in the Musée Nationale d'Art Moderne in Paris.

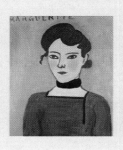

◆ MARGUERITE (1907)

The portrait of his daughter Marguerite completely eschews psychological connotations. Matisse does not seek to show her individuality, he does not aim at a realistic portrait, but works with color to create a decorative composition. The only characterizing element is the name written on the canvas, as in Eastern icons, which are also recalled in the frontal pose and the stylization. Purchased by Picasso, the painting is today in the Musée Picasso in Paris.

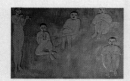

◆ LA MUSIQUE (1910)

La Musique and *La Danse*, today both in the Hermitage in St Petersburg, were commissioned in 1909 by the Russian art collector Sergej Shchukin for the grand stairwell in his house in Moscow. The two panels recall mythological horizons, the music of Pan's pipe, the primeval paradise of a still innocent world. The two canvases were confiscated during the October Revolution.

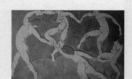

◆ LA DANSE (1910)

Made for the same patron and for a specific place, the two panels appear closely connected with each other. Not only do they share a common theme, but they are also unified stylistically. The blues of the skies, greens of the earth, and reds of the bodies, spread softly on the canvas, are common to both. The play of curved lines divides the composition into broad areas of uniform color.

◆ THE CONVERSATION (1911)

This painting as well, formerly in the Shchukin collection, is now in the Hermitage in St Petersburg and belongs to the phase of Matisse's work when he was feeling the influence of Russia. The colors and forms recall the five Byzantine enamels in the Louvre in Paris, which Matisse probably knew. The picture may depict a moment of conflict between the artist and his wife, the probable subjects of the painting.

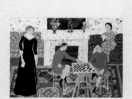

◆ THE PAINTER'S FAMILY (1911)

After showing *La Danse* and *La Musique* at the Salon d'Automne in 1910, Matisse escaped from the critics to Andalusia. The painting was born out of an intimate and protected environment, in the bosom of warm family affections. In the center his two sons Pierre and Jean, playing checkers, recall Cézanne's card players; his daughter Marguerite is standing and his wife is seated on the sofa.

◆ STILL LIFE WITH AUBERGINES (1912)

This canvas, now in the Musée de Peinture et de Sculpture in Grenoble, marks the birth of Matisse's grand ornamental style. The colors are still Fauvish, forceful, spread in broad areas, and the aubergines are depicted realistically but flattened on a table which has no depth. The decoration explodes on the canvas; fabrics, rugs, screens, and wallpaper are filled to bursting with floral motifs.

◆ MADAME MATISSE (1912-13)

Matisse painted his wife numerous times, especially in the early years of his career when he did not have enough money to pay models. In this picture, now in the Hermitage in St Petersburg, he explicitly cites the tribal art of African masks, which he had admired at the Ethnological Museum of the Trocadéro in Paris and collected with a passion. The facial features are stylized, devoid of any biographical notations.

◆ CALLA LILIES (1912-13)

Painted in Tangiers during Matisse's second trip to Morocco, the painting, purchased by Shchukin, is the ornamental study of a vegetable motif analyzed in its effects of light and color. The surfaces are light, almost transparent, emphasizing the fragility of the flowers. The background is rendered with uniform brushstrokes, the callas with rapid, light touches.

◆ ZORAH STANDING (1912)

Zorah is a young Arab prostitute, met in Tangiers during Matisse's first trip to Morocco. Under house arrest, the girl would receive Matisse's visit every morning to have him paint her portrait. Stylistically this canvas recalls Persian miniatures in the decorative richness of the colors, and Russian icons in the unusual elongation of the form and the frontal pose. Purchased by Shchukin, it is today in the Hermitage.

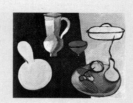

◆ GOURDS (1916)

The painting was made in the years of the First World War. The horrors of the war as it dragged on seemingly interminably and the losses, of painter friends as well, darken Matisse's palette. The forms are sharply cut out, the objects become symbols, nature becomes architecture, the contour lines are decisively defined. This is a plea for certainty in the darkness of war.

◆ THE MOROCCANS (1916)

Now in the Museum of Modern Art in New York, the painting was inspired by Matisse's second trip to Morocco. During the dark years of the First World War, the memories of warm African winters were a partial consolation to the artist. With *The Moroccans* he seeks refuge in the sun, the warmth, the luminous atmosphere of the southern Mediterranean and goes back in memory to a time that is distant from the pain of the conflict.

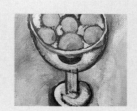

◆ BOWL OF ORANGES (1916)

Just as Cézanne had painted oranges on tables and in baskets, using daring angles of perspective, so did Matisse in 1916 try his hand at the theme, for him unprecedented. He approached representation in a wholly sculptural way. Guillaume Apollinaire stated that Matisse's oranges are fruits of pure color, crystallized as in an icon. The painting is one of the most synthetic products of Matisse's entire corpus.

◆ PORTRAIT OF SARAH STEIN (1916)

Sarah Stein, the sister-in-law of Leo and Gertrude Stein, was for many years a patron of Matisse. From 1905 to 1918 the Steins bought numerous pictures from the painter, promoting the knowledge and dissemination of his art in the United States. In this portrait the master reached the height of expression of the metaphysical dignity of the person, adopting the technique of Eastern icons.

◆ PORTRAIT OF AUGUSTE PELLERIN II (1916)

Showing a strong debt to Cézanne, this portrait takes its frontal pose and stylized physiognomy from Eastern icons. The clever geometrical games reveal a debt also to the italian tradition of painting. In painting this picture, Matisse declared that he was influenced decisively by the work of Giotto, Fra' Angelico, and Byzantine mosaicists.

◆ NUDE SEEN FROM THE BACK (1916)

From 1914 to 1917 Matisse used the technique of the monotype for new experiments with line. Monotypes are made by drawing with a stylus on a metal plate covered with ink, then placing a sheet of paper on the plate and applying pressure to create a print. The technique highlights the luminousness of the white line against the black ground.

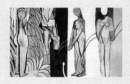

◆ GIRLS AT THE RIVER (1909-16)

Begun before the outbreak of the First World War, this painting, now in the Art Institute of Chicago, was interrupted and taken up again several times. Picasso's influence can be perceived, particularly in the Cubist analysis of the body. Front, profile, and back views of a nude divide the space into three parts, and geometry takes on a primary importance. The colors reflect the turmoil of the war.

◆ THE PIANO LESSON (1916)

This canvas, along with the one above, was shown in Paris at Paul Guillaume's gallery and attests the continuity of Matisse's aesthetic research in the years before and after the war. Geometry still dominates. Forceful lines intersect and divide the painted surface into blue, pink, and gray fields with strong blacks setting up a counterpoint. The intimacy of being emerges, and its relationship with music.

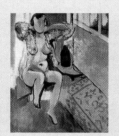

◆ NUDE WITH SPANISH RUG (1919)

This painting marks the beginning of the series of empty faces, one of the best known characteristics of Matisse's painted works. The facial features disappear, following the practice of Islamic art, and individuality is set aside. Maximum value is given, instead, to the decorative element and the use of color, which are accentuated in the rich representation of the setting.

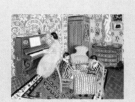

◆ PIANIST AND CHECKER PLAYERS (1924)

This canvas is the most representative of Matisse's period in Nice. Beckoned by the warm light and colors of the south of France, Matisse went to Nice for the first time in 1917, each time staying a little longer. The central figures take their inspiration from Cézanne's card players in their daring perspective and unnatural anatomy. On the right is a cast of Michelangelo's *Prisoners*.

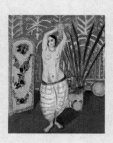

◆ ODALISQUE WITH GREEN PLANT AND SCREEN (1924)

Matisse painted more than fifty odalisques between 1919 and 1949: figures of beautiful Mediterranean women in indolent poses, captured in intimate moments. In this *Odalisque with Green Plant and Screen*, the master gives to the relaxed pose of the woman a richly decorated background of floral motifs.

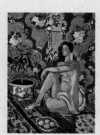

◆ DECORATIVE FIGURE ON AN ORNAMENTAL BACKGROUND (1926)

Even when representing female nudes in intimate moments, Matisse did not renounce his research into the modeling of volume. Increasingly fascinated by sculpture, he inserts the human figure, here made statuesque, into ever more complex decorative contexts. This is the case with this canvas, now in the Centre Georges Pompidou in Paris, a milestone in his artistic production.

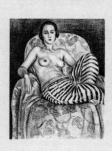

◆ LARGE ODALISQUE WEARING BAYADERE PANTS (1925)

Line is one of the basic instruments of Matisse's artistic expression. Synthetic, essential, incisive, his line hints at ideas and proves their existence. This lithograph reveals great skill at graphics and an expert hand. The play of light and shadow on the face and body is echoed in the calligraphic lines of the flowers on the armchair.

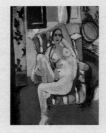

◆ SEATED NUDE WITH TAMBOURINE (1926)

This painting, with vague Cubist overtones in the figure in the foreground, is today in the Museum of Modern Art in New York. The room becomes a stage set for the model, and Matisse arranges in it the various decorative objects which he brought back with him from trips to the East. The female figure has the same importance as the fabric of the curtains or as the upholstery on the armchair.

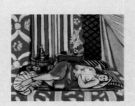

◆ ODALISQUE WEARING GRAY PANTS (1927)

The picture is in the Musée de l'Orangerie in Paris. Matisse declared that he was totally dependent on his models, leaving them free to move as they wished and observing them carefully for hours before deciding what pose to fix on the canvas. He studied them especially while they were at rest, abandoning themselves completely to the artist's eye as he sought to capture their most natural and new postures.

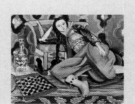

◆ ODALISQUE LEANING ON A TURKISH ARMCHAIR (1928)

In his long production of odalisques, Matisse harked back to the long tradition of nineteenth century French painting. This woman languidly reclining in a richly decorated interior offers herself defenseless to the painter's eye, which skillfully captures her forms and sensuality, her warm breath and odor. We have here a masterful composition combining visual and sensory experience.

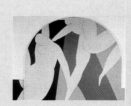

◆ THE DANCE (1931-32)

This is a large mural decoration commissioned by the American collector Barnes for the museum of his foundation in Merion, Pennsylvania. Matisse created on panels a joyous dance of bodies described with a few essential lines, reduced to symbols. The play of soft curves and delicate color tones continues in the already existing space of the wall, accentuating the monumental element of the architecture.

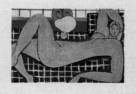

◆ LARGE RECLINING NUDE (PINK NUDE) (1935)

Matisse returned to work on this picture, now in the Museum of Art in Baltimore, a good twenty-four times. The model is his faithful Russian assistant Lydia Delectorskaya, an opposite type from the Mediterranean odalisques. The perfection of her form and the powerful volume of her body suggested a classical pose, practically without decoration, inspired by the models of Michelangelo.

◆ LARGE BLUE DRESS AND MIMOSAS (1937)

In this picture Matisse composes a synthesis between various techniques. The forms are flattened, the colors become increasingly uniform, the contours are traced with a line that seems to have been scratched into the canvas. The compositional structure is rhythmical and open, with regular forms that seems almost to have been cut out of the areas of color. They prefigure the *gouaches découpés*, paper covered with tempera and then cut into shapes.

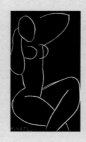

◆ SEATED NUDE WITH CROSSED LEGS (1941-42)

This linoleum print, now in the Bibliothèque Nationale in Paris, is part of a rich group of linocuts produced in his search for a purification of the sign. The outline becomes the protagonist, accompanying the absolute radiance of the body as it emerges from the black ground. Her form, even though only summarily sketched, has a strong physical presence.

◆ FIG LEAVES (1941)

During his convalescence after an operation in Lyon in 1941, Matisse made an extensive study of vegetable motifs, signaling his return to life with a vast production of line drawings. His long contemplation of vegetation, represented realistically, recalls the doctrines of Chinese paintings, which decree the complete absorption of the artist in nature.

◆ YOUNG WOMAN WITH A PEARL NECKLACE (1942)

Still in the vein of the *visages vides*, this canvas is characterized by its powerful use of the color red, which dominates space and wraps like a cloak around the summarily sketched body of the woman. On this sort of chromatic wall Matisse traces some vegetable motifs, as though scratched into the paint, which appear to arrange themselves like a crown around the model's head.

◆ THE DREAM (1940)

Matisse, in his continuing attention to decoration, was fascinated by some models wearing Romanian blouses of white material with geometric and floral motifs, and was inspired to paint a number of canvases with figures dressed in this way. The subject of this painting is the young Turkish woman Chawkat, great grand-daughter of the last Ottoman sultan Abdulamid II.

◆ MONIQUE (1942)

The model is Michaela Avogadro, posing in Matisse's room at Villa Le Rêve in Vence. The painter shows no interest in rendering the woman's biographical identity. He eliminates completely the facial features and plays on volumes, broken lines, and her voluptuous and provocative pose. A preparatory drawing in pen and ink on paper exists of this oil on canvas.

◆ THE FLIGHT OF ICARUS (1947)

In 1947 Tériade published *Jazz*, Matisse's masterpiece of a book composed of twenty lithographs and a text of poetry. He begins a new technique of expression: the master takes sheets of paper painted with tempera and cuts them out to form figures. These are the *papiers découpés*, an ultimate fusion of light and color which dance in the composition, by now its only protagonists.

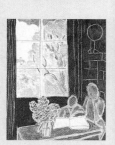

◆ LE SILENCE HABITÉ DES MAISONS (1947)

The title of this painting, *The Inhabited Silence of Houses*, is a quote from the poem, *Matisse parle* (Matisse speaks), edited in 1947 by Louis Aragon. Two figures very close to each other read in a dark room, as though illuminated by a yellow glow. Through the window behind them stretches a luxuriant landscape. Matisse reaches the height of his expressive power using only color and line.

◆ INTERIOR WITH EGYPTIAN CURTAIN (1948)

This painting is a marvelous example of the art of interiors, a master work of Matisse's handling of decoration and colors. A strong light pours in through the window, borne on the branches of a palm tree reflecting the sun, and on the table a bowl of oranges gives depth to the composition. The fabric of the curtain in the foreground would be a source of inspiration for the textile industry of the time.

◆ THE LAGOON

Confined to a wheelchair for more than ten years and now approaching the end of his life, Matisse was tired and painting was exhausting for him. But he invented a technqiue which would still allow him to express his creativity: his *gouaches découpées*, sheets of paper painted with tempera and cut out. At the beginning still showing some connection to figurative representation, they would become increasingly abstract, the absolute protagonists of a musical universe.

◆ KATIA IN A YELLOW SHIRT (1951)

This oil on canvas may be Matisse's last painting, as he by now devoted himself to making *gouaches découpées*. The figure no longer has a central position, the body is sketched in summarily, recalling geometrical volumes. The brushstrokes are random and rapid. The woman's skirt still shows the love of decoration of a man who was ill but still productive.

◆ CHRISTMAS EVE (1951)

Line and color by now dominate the master's compositions. The forms, synthesized to the utmost, become symbols. Matisse expresses the joy and serenity of his old age. At 82 he is still playing with color, and he consecrates his art to history and to painting. His new technique allows him to set free feelings and senses from the prison of his infirm body.

◆ BLUE NUDE III (1952)

His sheets painted with tempera and then cut out represent Matisse's most synthetic work. The painter achieves the highest fusion of the arts of painting and music in a profusion of light and color. This *Blue Nude* is still constructed figuratively, but the form approaches abstraction and the white surface receives pure the color of the sky and the sea, the color of the infinite.

◆ THE TREE OF LIFE (1949)

From 1948 to 1951 Matisse devoted himself to the decoration of the Chapel of the Rosary in Vence, which he started almost as a game in order to thank the Dominican nuns who took care of him in the hospital after his operation. *The Tree of Life* is made of two panels of stained glass windows in the chapel apse. The artist prepared two other plans before arriving at this creation.

◆ BOOK ILLUSTRATIONS

Forced to curtail his physical activities, Matisse began working in the 1940s in the publishing field, illustrating literary texts: six engravings for James Joyce's *Ulysses* and fifty-two for Mallarmé's poetry. In 1944 he made a series of images for *Pasiphae* by Henry de Montherlant, emerging with a personal style which was widely appreciated and in great demand.

◆ RECLINING NUDE (1907)

Matisse's sculpture production was vast: more than 300 statues, almost all small in size. His interest in sculpture was very strong, and when he began collecting African fetishes, he tried to effect a transposition of the procedures of the plastic art into painting. This small bronze is part of a long series of statuettes representing the same pose.

TO KNOW MORE

The following pages contain: some documents useful for understanding different aspects of Matisse's life and work; the fundamental stages in the life of the artist; technical data and the location of the principal works found in this volume; an essential bibliography

DOCUMENTS AND TESTIMONIES

The Paris Critic

Guillaume Apollinaire was one of the first critics to consider Matisse's paintings. On December 18, 1907, in the second issue of the magazine La Phalange, *he told of his encounter with Matisse's work, placing the accent on the friendly nature of his relationship with the painter.*

"Here is a timid essay on an artist in which I believe are combined France's tenderest qualities: the strength of simplicity and the softness of the light.

There is no relationship between painting and literature, and I have tried not to arouse the slightest confusion in this sense. Certainly, for Matisse, plastic expression is an end, just as lyric expression is an end for the poet.

When I approached you, Matisse, the crowd had looked at you and was laughing; you smiled back in reply. They saw a monster where a marvel was standing. I asked you questions, and your answers expressed the reasons for the balance of your reasonable art. 'I worked,' you said, 'to enrich my mind by satisfying the various curiosities of my spirit, making an effort to get to know the different ways of thinking of the old and modern masters of the plastic arts. This was also a material labor because at the same time I was trying to understand their technique.'

Then, pouring me a glass of *rancio*, the old wine you had brought from Collioure, you chose to tell me the ups and downs of this risky journey toward the discovery of your personality. One goes from learning to awareness, that is to say, to forgetting completely everything that is not part of oneself.

'Then,' you said to me, 'I discovered myself by looking at my first works all over again. I found something that was always similar: at first glance I thought it was a repetition which could cause my pictures to be monotonous. Instead, it was the manifestation of my personality which always came out the same, no matter what my state of mind, among the many that I have gone through.'

'I made an effort to develop this personality of mine, trusting above all to instinct, returning often to the beginnings. And if in my work some difficulty was blocking me, I would repeat to myself: I have paints, a canvas, and I have to express myself with sincerity, even if I should happen to do it summarily: I will put four or five patches of color and I will draw four or five lines, but they have to have a plastic expression.'

Often, dear Matisse, they reproach you for this synthetic expression, without thinking that in this way you have done one of the most difficult tasks: to give a plastic existence to a picture without recourse to the object except to stimulate sensations. The eloquence of your works derives mainly from the combination of the colors and lines. This, and not the simple reproduction of an object, constitutes the painter's art.

Henri Matisse gives warmth to his concepts, he constructs pictures with colors and lines to the point of breathing life into his combinations: following their own logic these then form a final composition, from which neither a color nor a line could be taken away without reducing the whole to a casual juxtaposition of random lines and colors."

Apollinaire reported Matisse's testimony concerning the origin of his painting, highlighting the European and non-European influences which constitute the reasons for Matisse's art.

"'I have never avoided the influence of others. I would have considered it to be cowardice and a lack of sincerity toward myself. I believe that the artist's personality is developed and affirmed in the struggles he goes through against others' personalities. If the struggle is fatal for him, if he succumbs, that was his destiny.'

As a consequence, all the plastic languages, the hieratic nature of the Egyptians, the extreme refinement of the Greeks, the sensual delight of the Cambodians, the products of ancient Peru, African statuettes, to the degree to which they are proportionate to the passions which inspired them, can interest an artist, helping him to develop his personality. Comparing his painting constantly with other artistic conceptions, widening his spiritual interest to the arts that are close to the plastic arts, Henri Matisse, whose already rich personality would have been capable of development even in isolation, ripened the magnificence and confident pride which distinguish him.

But, as curious as he is to know the artistic habits of all the races of man, Henri Matisse remains above all devoted to the beauty of Europe. Thus he looked to Giotto, to Piero della Francesca, to the early Sienese painters, to Duccio, less interesting from the viewpoint of volume but with a greater spiritual power. Then he meditated on Rembrandt. Finally, stopping at the crossroads of painting, he looked within himself to find the road which his conquering instinct would follow blindly. We are not faced here with an extremist attempt: the prerogative of Matisse's art is to be reasonable. It might be passionate or tender, and it expressed itself so purely that anyone could understand it. This painter's awareness is the result of his knoweldge of other artistic awarenesses. He owes his plastic newness to instinct, that is to say, to self-knowledge."

The perceptive impact with a face

In his preface to Portraits, *Matisse explains his love of portraits.*

"The human face has always interested me a great deal. I also have a very good memory for faces, even those only seen once. Looking at them, I don't try to understand their psychology, but I am struck by their expression which is often special and profound. I have no need to formulate in words the interest they arouse in me; they strike me probably with their expressive characteristic and with an interest that is exclusively plastic. It is from the perceptive impact with a face that the main sensation is born which sustains me constantly throughout the entire execution of the portrait."

The play of line

Sarah Stein was a witness to Matisse's teachings to his students, publishing them in Alfred Barr's book, Matisse, his art and his public *(New York 1951).*

"Remember that a line cannot exist by itself; it always foresees a companion. Never forget that a line does not express anything; it is only in relationship with another line that it creates volume. And the two must be drawn together.

I have always thought that this simple means could be compared to a violin and its bow; a surface, a chisel, four stretched strings, and a tuft of horsehair."

1869. Henri Matisse born on December 31 in Le Cateau-Cambrésis, in the north of France. His father was a well-to-do merchant.

1888. Studied law at the University of Paris.

1889-1890. Worked in a lawyer's office in Saint-Quentin, a town near his home, and, after spending most of the year in bed because of an intestinal ailment, began taking drawing lessons from Quentin de la Tour.

1891. Abandoning law studies altogether, he enrolled in the Academie Julien in Paris to prepare under Prof. Bouguereau for the admission exam to the Ecole des Beaux-Arts.

1892. He did not pass the exam, but was invited in any case by Gustave Moreau, just recently named a professor at the Ecole des Beaux-Arts, to take lessons in his own studio and at the Louvre. At the same time he enrolled in the Ecole des Arts Décoratifs, where he became friends with Marquet.

1894. On September 3, his daughter Marguerite was born.

1896. Exhibited four paintings at the Salon de la Société Nationale des Beaux-Arts, encountering a certain amount of acclaim. The French State purchased *Woman Reading*.

1898. On January 8 married Amélie Parayre, mother of Marguerite, and went to London to see the Turner collection.

1899. After the death of Moreau, left the Ecole des Beaux-Arts to frequent the atelier of Carrière, where he met Derain. Bought *Three Bathers* by Cézanne, a plaster cast by Rodin, a canvas by Gauguin, and a drawing by Van Gogh.

On January 10, his son Jean was born.

1900. On June 13, his youngest child Pierre was born.

1901. Visiting a retrospective exhibition of Van Gogh at the Bernheim-Jeune Gallery, he met Vlaminck. Exhibited at the Salon des Indépendants presided over by Paul Signac.

1903. Participated in the Salon d'Automne and visited a show of Islamic art at the Musée des Arts Décoratifs in Paris.

1904. Organized his first personal exhibition at the gallery of Ambroise Vollard.

With Signac and Cross, spent the summer in Saint-Tropez. Painted *Luxe, calme et volupté*, experimenting with Divisionist technique.

1905. With Derain, spent the summer in Collioure, on the Mediterranean coast, where he worked with pure colors. Exhibited his new Fauve experiments at the Salon d'Automne.

1906. Painted *The Joy of Life*, exhibited at the Salon des Indépendants.

Took his first trip to Africa, to Algeria (Algiers, Batna, Constantine, Biskra), where he fell under the spell of the local textiles and pottery.

1907. Began frequenting the salon of Gertrude Stein, where he met Picasso. Spent the summer in Italy, guest of the Steins in Fiesole. Visited Florence, Arezzo, Siena, Padua, Ravenna, and Venice.

1908. His text on theory *Notes d'un peintre* (Notes of a painter) was published in the *Grande Revue*, an avant garde magazine.

His first personal exhibition was held in New York, promoted by Gertrude Stein.

1909. The Russian collector Shchukin commissioned two decorative panels for his house in Moscow. Matisse worked on *La Danse* and *La Musique* for the entire next year.

1911. Went to Moscow to see to the installation of his two canvases in Shchukin's house.

Trip to Morocco.

1914. Exempted from military duty, he settled in Collioure with his family. Sent food and other comforts to his friends Derain and Camoin at the front. Worked intensely throughout the entire duration of the war.

1919. Stayed in London to create the stage sets for Diaghilev's Russian Ballet *The Song of the Nightingale*.

1923. His daughter Marguerite married Georges Duthuit, art critic and Byzantinist.

1924. Began painting the odalisques.

1927. Received the Carnegie International Exhibition Prize in Pittsburgh.

1930. Traveled to the United States and Tahiti. Received the commission for a large *Dance* from the collector Barnes in Merion, near Philadelphia.

A series of important exhibitions (New York, Berlin, Paris) consecrated Matisse's international fame.

1932. Worked on thirty etchings for an edition of Mallarmé's *Poésies*.

1937. Accepted the commision for the sets and costumes of the Russian ballet *Red and Black* (*The Strange Farandole*).

1939. Separated from his wife, he went to live in the old Hotel Régina in Cimiez.

1940. When the Germans invaded Paris, went to Bordeaux, refusing to flee to Brazil.

1941. Successfully operated on in Lyon for duodenal cancer. After his convalescence, returned immediately to painting.

1943. Cimiez bombed. Matisse moved to Vence, in the hills above Nice.

1944. His wife and daughter arrested and deported by the Gestapo for their activities on behalf of the French Resistance movement. Worked on illustrations for *Les fleurs du mal* by Baudelaire.

1947. The publisher Tériade issued *Jazz*, Matisse's new proposal for art, his *gouaches découpées*.

1948. Began working on the Chapel of the Rosary in Vence, which would be consecrated on June 25, 1951.

1950. Awarded the prize of the XXV Biennale d'Arte in Venice.

1951. Definitively stopped painting on canvas and devoted his efforts solely to making *gouaches découpées*. Alfred Barr published his monograph on the painter.

1952. The Musée Matisse inaugurated in Le Cateau-Cambrésis.

1954. Matisse died in Nice on November 3, after a brief illness.

The following is a catalogue of the principal works by Matisse conserved in public collections. The list of works follows the alphabetical order of the cities in which they are found. The data contain the following elements: title, dating, technique and support, size in centimeters, location.

BALTIMORA (UNITED STATES)

Blue Nude 1907; oil on canvas, 92x141; Museum of Art.

Large Reclining Nude, 1935; oil on canvas, 66x92; Museum of Art.

Woman Sitting on a Red Chair, 1936; oil on canvas, 34x23; Museum of Art.

BASEL (SWITZERLAND)

The Manila Shawl, 1911; oil on canvas, 112x69; Rudolf Staechelin Familienstiftung.

CHICAGO (UNITED STATES)

Large Interior in Nice, 1919; oil on canvas, 63x45; Art Institute.

Girls at the River, 1916; oil on canvas, 262x391; Art Institute.

VATICAN CITY

The Tree of Life, 1949; gouache on cut-out and pasted paper, 515x252; Collection of Modern Religious Art.

COPENHAGEN (DENMARK)

Luxe II, 1907-08; oil on canvas, 210x139; Staatens Museum for Kunst.

Zulma, 1950; cut-out and pasted paper, 2368x1330; Staatens Museum for Kunst.

Odalisque with Green Plant and Screen, 1924; oil on canvas, 55x38: Staatens Museum for Kunst.

GRENOBLE (FRANCE)

Interior with Aubergines, 1911; oil on canvas, 210x245; Musée des Beaux-Arts.

Still Life with Red Cloth, 1906; oil on canvas, 89 x 116.5; Musée de Grenoble.

Pink Nude, 1909; oil on canvas, 33x41; Musée des Beaux-Arts.

LONDON (GREAT BRITAIN)
Portrait of Derain, 1905; oil on canvas, 39x29; Tate Gallery.
Standing Nude, 1907; oil on canvas, 92x64; Tate Gallery.

MERION-PENNSYLVANIA (UNITED STATES)
Madame Matisse: Red Madras, 1907; oil on canvas, 99x81; Barnes Foundation.
The Dance, 1931-32; oil on wood, three panels: 340x387, 355x498, 333x391; Barnes Foundation.
The Joy of Life, 1905-06; oil on canvas, 175x240; Barnes Foundation.
Seated Arab Man, 1913; oil on canvas, 200x159; Barnes Foundation.
The Red Armchair, 1919; oil on canvas, 35x56; Barnes Foundation.
Girl and Screen, 1919; oil on canvas, 33x41; Barnes Foundation.

MILAN (ITALY)
Odalisque, 1925; oil on canvas, 81x55; Museo d'Arte Contemporanea.

MOSCOW (RUSSIA)
Goldfish, 1911; oil on canvas, 140x98.
Vase of Nasturtiums with "La Danse", 1912; oil on canvas, 194x114; Pushkin Museum.
Zora on the Terrace, 1912; oil on canvas, 116x100; Pushkin Museum.

NEW YORK (UNITED STATES)
The Red Atelier, 1911; oil on canvas, 180x220; Museum of Modern Art.
The Blue Window, 1913; oil on canvas, 130x90; Museum of Modern Art.
View of Notre Dame, 1914; oil on canvas, 147x94; Museum of Modern Art.
Gourds, 1916; oil on canvas, 65x81; Museum of Modern Art.
Seated nude with Tambourine, 1926; oil on canvas, 73x54; Museum of Modern Art.
Periwinkles (Moroccan Garden), 1912; oil on canvas, 117x81; Museum of Modern Art.
The Moroccans, 1916; oil on canvas, 181x279; Museum of Modern Art.
The Piano Lesson, 1916; oil on canvas, 245x173; Museum of Modern Art.
Nude Man, 1900; oil on canvas, 100x72; Museum of Modern Art.

PARIS (FRANCE)
The Painter in his Studio, 1916; oil on canvas, 146x97; Centre Georges Pompidou.
Marguerite, 1907; oil on canvas, 65x54; Musée Picasso.

Odalisque with Red Pants, 1921; oil on canvas, 57x84: Centre Georges Pompidou.
Decorative Figure on an Ornamental Background, 1925; oil on canvas, 131x98; Centre Georges Pompidou.
Blue Nude II, 1952, cut-out and pasted paper, 116.2x88.9; Musée National d'Art Moderne.
The Three Sisters, 1917; oil on canvas, 91x74; Musée National d'Art Moderne (Walter-Guillaume Collection).

PHILADELPHIA (UNITED STATES)
The Moorish Screen, 1921; oil on canvas, 115x96; Museum of Art.
Large Blue Dress and Mimosas, 1937; oil on canvas, 61x73; Museum of Art.

PITTSBURGH (UNITED STATES)
A Thousand and One Nights, 1950; cut-out and pasted paper, 259x321; Carnegie Museum of Art.

SAN FRANCISCO (UNITED STATES)
Woman with a Hat, 1905; oil on canvas, 80.6x59.7; Museum of Modern Art.
Marina, 1905; oil on canvas, 28x35; Museum of Modern Art.

SAINT PETERSBURG (RUSSIA)
La Musique, 1910; oil on canvas, 260x390; Hermitage.
La Danse, 1910; oil on canvas, 260x389; Hermitage.
The Conversation, 1908-12; oil on canvas, 177x217; Hermitage.
Moroccan Café, 1913; oil on canvas, 177x217; Hermitage.
The Roofs of Collioure, 1905; oil on canvas, 59.5x73; Hermitage.
Woman on the Terrace, 1906-07; oil on canvas, 65x80.5; Hermitage.
Vases and Fruit on a Red and Black Rug, 1906; oil on canvas, 61x73; Hermitage.
Two-handled Vase, 1907; oil on canvas, 19x24.5; Hermitage.
The Painter's Family, 1911; oil on canvas, 210x245; Hermitage
The Vase of Irises, 1912; oil on canvas, 118x100; Hermitage.
Zorah Standing, 1912; oil on canvas, 146x61, Hermitage.
Standing Arab Man, 1912; oil on canvas, 146.5x97.7; Hermitage.
Lady in Green, 1909; oil on canvas, 65x54; Hermitage.
Madame Matisse, 1912-13; oil on canvas, 145x97; Hermitage.

BIBLIOGRAPHY

The following bibliography is purely selective. Consultation of the general catalogues of Matisse's work is helpful for further study of the periods which characterized his artistic development.

1920 M. Sembat, *Matisse et son oeuvre*, Paris

1951 A. Barr, *Matisse, His Art and His Public*, New York

1952 André Verdet, *Les Prestiges de Matisse*, Paris

1953 Francis Caro, *L'ami des peintres*, Paris

1954 G.Diehl, *Henri Matisse*, Paris

1956 G. Duthuit, *Matisse période fauve*, Paris

1957 W.S. Liebermann, *Matisse, 50 Years of His Graphic Art*, London

1966 J. Leymarie, H. Read, W.S. Liebermann, *Henri Matisse*, Berkeley-Los Angeles

1967 M. Marchiori, *Henri Matisse*, Paris

1970 R. Fry, *Matisse et le renouveau de l'expression plastique*, Paris

1971 M. Carrà, *L'opera di Matisse dalla rivolta "fauve" all'intimismo. 1904-1928*, Milan
J. Flam, *Matisse's Back and the Development of his Painting*, London
L. Aragon, *Henri Matisse, roman*, Paris

1978 *Henri Matisse*, exh. cat., Rome

1979 Henri Matisse, *Scritti e pensieri sull'arte*, Turin

1983 M. Duthuit-Matisse and C. Duthuit, *Henri Matisse, catalogue raisonné de l'oeuvre gravé*, Paris
J. Guichard-Meili, *Les gouaches découpés de Henri Matisse*, Paris

1987 Jacqueline and Maurice Guillaud, *Matisse. Le rythme et la ligne*, Paris-New York
P. Schneider, *Matisse et l'Italie*, exh. cat., Venice

1989 Jacqueline and Maurice Guillaud, *Matisse*, in *Art Dossier* no. 33

1997 *Matisse, la révélation m'est venue de l'Orient*, exh. cat., Rome

ONE HUNDRED PAINTINGS:

every one a masterpiece

———— Also available: ————

Raphael, Dali, Manet, Rubens,
Leonardo, Rembrandt, Van Gogh,
Kandinsky, Renoir, Chagall

Vermeer
The Astronomer

Titian
Sacred and Profane Love

Klimt
Judith I

Matisse
La Danse

Munch
The Scream

Watteau
The Embarkment for Cythera

Botticelli
Allegory of Spring

Cézanne
Mont Sainte Victoire

Pontormo
The Deposition

Toulouse-Lautrec
At the Moulin Rouge

———— Coming next in the series: ————

Magritte, Modigliani, Schiele,
Poussin, Fussli, Bocklin, Degas,
Bosch, Arcimboldi, Redon

DATE DUE